DISCOVER DRAWING

MW01034754

Draw Real Hands!

Lee Hammond

NORTH LIGHT BOOKS

Cincinnati, Ohio

01 00 99 98 97 5 4 3 2 1

Library of Congress Cataloging-in-Publication Data

Hammond, Lee.
 Draw real hands! / by Lee Hammond.
 p. cm.
 Includes index.
 ISBN 0-89134-817-4 (alk. paper)
 1. Hand in art. 2. Drawing—Technique. I. Title.
NC774.H19 1997
743.4'9—dc21 97-17103
 CIP

Edited by Julie Wesling Whaley
Production edited by Patrick G. Souhan
Interior and cover designed by Mark Larson

North Light Books are available for sales promotions, premiums and fund-raising use. Special editions or book excerpts can also be created to specification. For details, contact Special Sales Manager, F&W Publications, 1507 Dana Avenue, Cincinnati, Ohio 45207.

DEDICATION

This book is dedicated to Gus Freeman, my friend and business partner. Thank you for your loyal friendship and unyielding support. Without your dedication to my dream and commitment to our business, I would not be where I am today. Thank you so much for becoming my manager, and "kicking me off the cliff so I could fly."

About the Author

Polly "Lee" Hammond is an illustrator and art instructor from the Kansas City area. Although she was raised in Lincoln, Nebraska and has lived all over the country, she calls Kansas City home.

She is now the owner of a new teaching studio, the Midwest School of Illustration and Fine Art, and art supply store, Midwest Art and Frame. At the stuio, she teaches artists of all ages. She covers a variety of art techniques and mediums, focusing on portraits and realism. Her studio is located in Lenexa, Kansas, a Kansas City suburb.

Lee has been an author for North Light Books since 1993. She is also a traveling seminar instructor, demonstrating and teaching various art techniques as well as the Prismacolor line of art products.

She has three children, Shelly, LeAnne and Christopher, and one granddaughter, Taylor. They all reside together in Overland Park, Kansas.

ACKNOWLEDGMENTS

As the saying goes, "You find out who your friends are." Over the last year, nothing could be more true! Turbulent times truly do show what people are made of, and I am grateful every day for the quality of friendships I have surrounding me.

Thank you is not strong enough to express how I feel about the support I have received. I am a very lucky person. Not a day goes by that I am not completely appreciative of all that I have.

I want to start by thanking David Lewis for once again asking me to work with the North Light family. I will always work my hardest to provide the quality of work worthy of the North Light name. Also, thank you to my editor, Julie Whaley, for being so kind and understanding. You have become a great friend!

I especially want to thank my wonderful friends who have helped to keep me focused with their encouragement. It has been a dream of mine to open an art school and provide my fellow artists with a place to share their art. Thanks to the undying support and love of many people, that dream is now a reality. I hope we have many years of creativity together.

A very special thanks must go to Laura Tiedt, Carla Sapienza and Lanny Arnett, who are always there when I need them. I love you guys more than you'll ever know!

CONTENTS

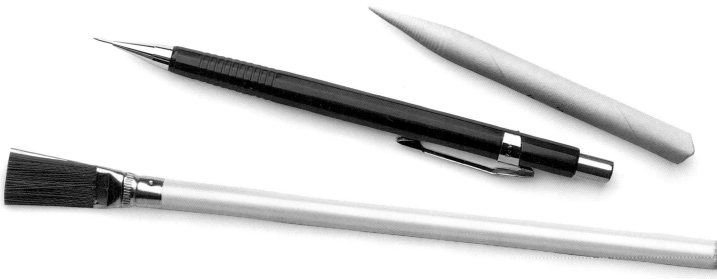

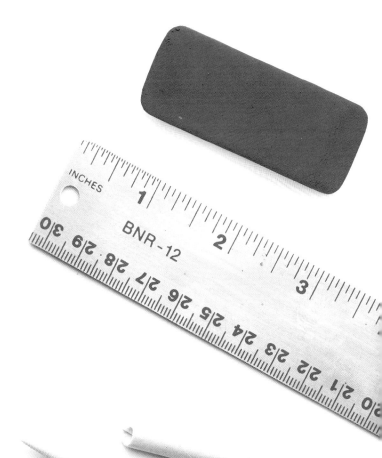

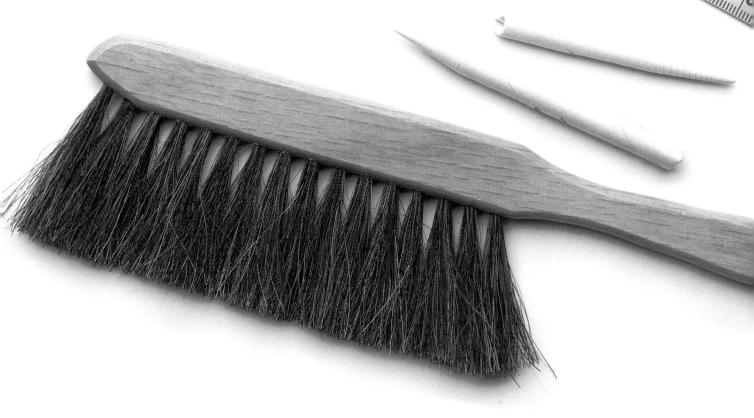

INTRODUCTION

No thought or idea is truly original or new. Though this book is new in terms of presentation, the facts and material date back to when man first held a drawing tool and drew his interpretation of his surroundings.

It is my hope that by writing these art instruction books, I can present the material in a way that is clearer than you've heard it before and more obtainable in your artwork and drawings.

Do not be afraid to try. Experiment through trial and error. I am a self-taught artist: I learned by making mistakes and discovering what *doesn't* work through pure study. The more you study something, the clearer the material becomes. And with art, the more you practice, the better your skills become. You always get out what you put into something.

Hands have always been a trouble for artists—one of the weak links in the chain of artistic subject matter. But, as with anything else, you can learn how to draw them through hard work and practice. You must be diligent in your efforts. If you break it down and study what really makes a hand look the way it does, drawing it becomes easier. This book is designed to take some of the mystery out of drawing hands, so you, too, can make them look real in your artwork.

CHAPTER ONE

WHY IS IT SO HARD TO DRAW HANDS?

People say faces and hands are the hardest things to draw. But *why*? What is it about faces and hands that make them so difficult for the artist? I have my own theory on that. After years of teaching art, I see one common trait we all share. We think in general terms, simplifying things in our memories. And in our recall, we remember the basics, such as the overall shape, but many of the smaller details are left out. We are left with a very simplistic impression of what we first saw.

The goal of this book is to make you really look at what you are drawing—to see the things you usually miss in everyday observation. Then, by breaking down what you see into step-by-step procedures, you can learn a process that applies to everything you draw. You *can* become an expert at drawing hands. And no longer will you be tempted to leave them out of your drawing, or, worse yet, to draw a pocket or mitten to put them in.

A simple drawing of a hand by a child. Notice how general the shapes are, with no details such as joints. Our memories of objects always give us simplistic impressions.

In this example, the child's memory has provided the basic shapes—one large part with five smaller parts coming off of it. The fingers and the thumb are all coming off the top.

By having the child trace around his hand, the shapes are still very simple but more realistic in their placement. Notice how the thumb is now lower.

WHY IS IT SO HARD TO DRAW HANDS? **9**

A child's handprint. Unlike the oversimplified, rounded impression seen in the child's drawings, this one shows more shape. Look closely and you will see the fingers divided into three segments. The palm is divided into two segments with the thumb coming off the side and not the top.

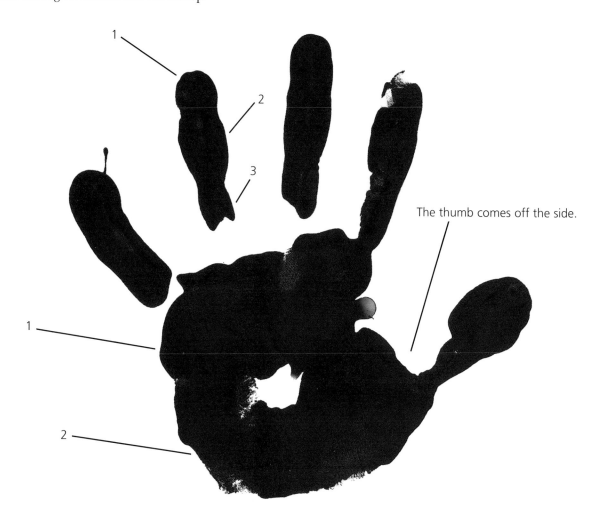

The thumb comes off the side.

BEFORE AND AFTER

I gave a picture of a hand to one of my students who professed that she was terrible at drawing hands. She avoided drawing them at all cost. It was just the challenge I needed. I wanted to prove to her that she *could* draw hands just by looking at them differently.

As you can see, we both succeeded. I revealed the process to her that I will be showing you in this book. By following directions and studying hands, she found that drawing hands was easier than she ever imagined.

By mastering the proper use of the drawing tools and the "tricks" that can be done with them, this student completed an excellent drawing of a hand. It is a true illustration (shown at right) as opposed to an overly simplified cartoon impression of a hand.

In this book, you will learn that blending and shading tones are the keys to realism in your drawings. Identifying the light source (in this case, the upper left) and correctly placing the shadows (the back of the hand and wrist) gave this student an accurate picture of what a hand really looks like. You can do it too!

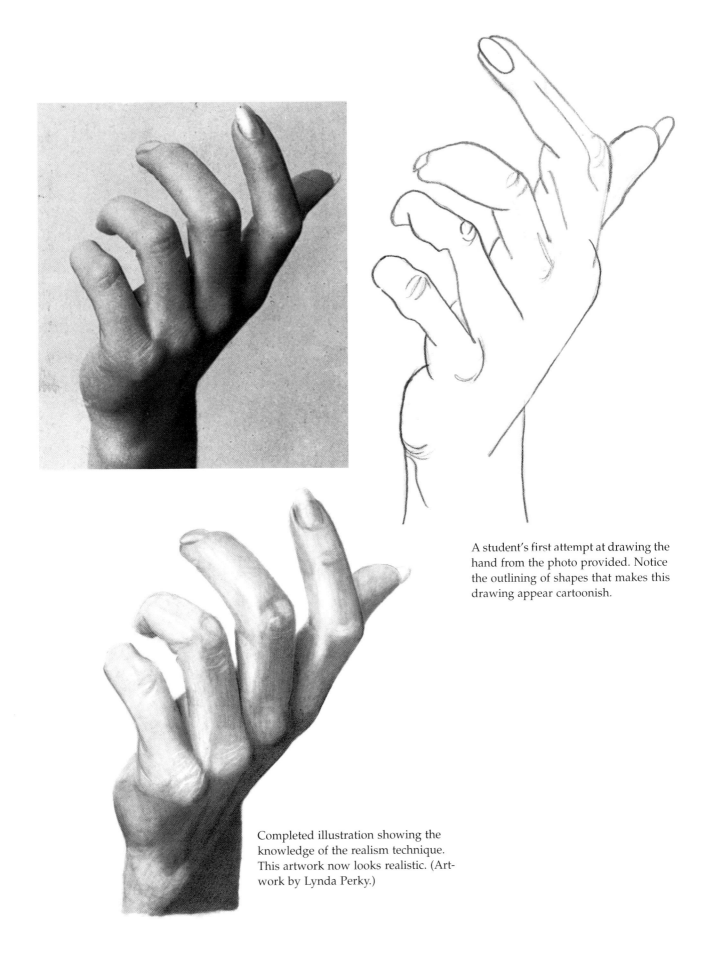

A student's first attempt at drawing the hand from the photo provided. Notice the outlining of shapes that makes this drawing appear cartoonish.

Completed illustration showing the knowledge of the realism technique. This artwork now looks realistic. (Artwork by Lynda Perky.)

MATERIALS YOU'LL NEED

To get professional results, you'll need to use quality materials. You don't have to spend a fortune, but you owe it to yourself to buy the proper drawing tools. Here's what I recommend.

Smooth Bristol Boards or Sheets—Two-Ply or Heavier

This paper is very smooth (plate finish) and can withstand the rubbing associated with the technique I will be showing you.

5mm Mechanical Pencil With 2B Lead

The brand of pencil you buy is not important. All mechanical pencils come with an HB lead, but you'll need to replace it with a 2B lead.

Blending Tortillions

These are spiral-wound cones of paper. They are *not* the same as harder, pencil-shaped stumps, which are pointed at both ends. Blending tortillions are better for my technique. Buy both large and small.

Kneaded Eraser

These erasers resemble modeling clay and are essential to this type of drawing. They gently "lift" highlights without ruining the surface of the paper.

Typewriter Eraser With a Brush on the End

These pencil-type erasers are handy due to the pointed tip, which can be sharpened. They are abrasive in nature and erase stubborn marks, but can also rough up the paper.

A 5mm mechanical pencil and blending tortillions.

Pink Pearl or Vinyl Eraser

These erasers are meant for erasing large areas and lines. They are soft and nonabrasive, and will not damage your paper.

Horsehair Drafting Brush

These wonderful brushes will keep you from ruining your work if you use them to brush away erasings. If you brush away erasings with your hand, you'll smear your pencil work. If you blow the erasings away, you could inadvertently spit on your work. Use the brush instead!

Workable Spray Fixative

This is used to seal and protect your finished artwork. It is also used to "fix" an area of your drawing so that it can be darkened by building up layers of tone. The word "workable" means you can still draw on your drawing after it has been sprayed.

Drawing Board

It is important to draw with your work tilted toward you to prevent distortion from working flat. A board with a clip to secure your paper and photo works the best.

Ruler

This is used for graphing and measuring.

Acetate Report Covers

These are used for making graphed overlays to place on your photo references. They help you grid what you are drawing, which increases your accuracy.

Magazines

These are valuable sources of practice material. Collect magazine pictures and categorize them into files for quick reference.

A typewriter eraser and Pink Pearl vinyl eraser.

A horsehair drafting brush.

CHAPTER THREE

SHAPES AND SHADING

To draw hands using my blended pencil technique and photographs for reference, there are two essential elements that must be mastered: shape and gradual blending.

Using Graphs

To obtain an accurate line drawing when using photo references, the use of a graph, or grid, can help. Placing a grid overlay on top of the photo breaks the subject matter down into manageable shapes. By drawing a light pencil grid on your drawing paper and then drawing what you see, box by box, you will draw more accurately than you would if you were to draw freehand. It forces you to see your subject matter in an abstract way—more like a grouping of shapes that fit together to create an object.

The following is an exercise to help you see things simply as shapes.

Each one of these boxes has a number and shape drawn in it. None of these shapes by themselves means anything. In each box of the empty graph, draw what you see, by placing the shapes in the corresponding numbered box. Do not try to figure out what you are drawing, because then you will try to draw from memory instead of drawing what you are looking at. Be as accurate as possible when you draw these shapes.

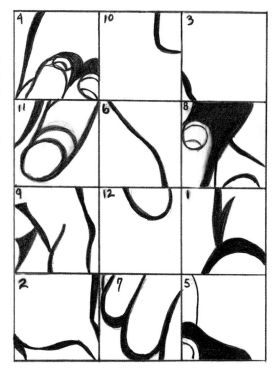

When you are finished with the puzzle, turn your work upside down. Note: If you do not want to draw in your book, photocopy these puzzles.

SMOOTH BLENDING

Creating a smooth blend from dark to light is the next important technique to use with this style of drawing. While it looks simple, it requires a lot of practice to make the blend appear very smooth and gradual.

Practice drawing a value scale using your pencil and tortillions. Be sure to build the dark areas gradually, evenly applying your pencil lines up and down in the same direction. Soften your touch as you progress to the right, lightening the tones as you go. Try to make the fade as gradual as possible, without any choppiness or separation in tones, until the tone fades into the white of the paper.

Use one of your tortillions to do the blending. Use it the same way you did the pencil, going over your drawing to blend the tones together. Use the tortillion at a slight angle so you do not push on the point. Apply it in the same direction that you applied the pencil lines, softening your touch until it fades into nothing.

You should not be able to see where one tone ends and another begins. If choppiness does occur, there are tricks you can use to fix it. First, squint your eyes while looking at your drawing. This helps blur your vision and allows you to see the contrasts in tone more easily. The dark areas will appear darker, and the light areas will appear lighter. This makes any irregularities stand out.

Should you see any unwanted dark spots in the drawing, take a piece of your kneaded eraser and roll it between your thumb and forefinger to create a point. Gently lift the dark spot out with the eraser, stroking it lightly. Never dab at it. I call this "drawing in reverse," since it is actually a controlled technique. Should you see any small light areas that shouldn't be there, lightly fill them in with your pencil.

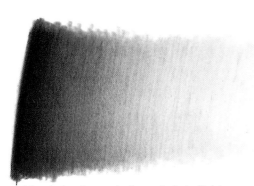

A blended value scale from dark to light.

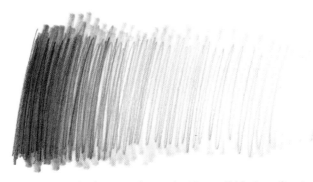

An incorrectly drawn value scale. The scribbled application of pencil lines makes this scale impossible to blend out evenly.

A tortillion is nothing more than paper wrapped into a cone shape. Never use the tortillion on its tip; it will cause the tip to collapse.

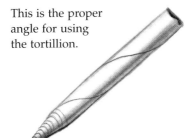

This is the proper angle for using the tortillion.

If the tip of a tortillion should become blunt, straighten out a large paper clip and stick it into the end of the tortillion to push the point back out.

SHADING IN ACTION

To apply blending and shading to your drawing, you must first try to understand what that shading represents. Shading represents the tones of the object and how the object's color is affected by light and shadows. These tones are broken down into five elements and are best illustrated on the sphere. It is important to learn all five of these elements and the roles they play. Here's a step-by-step lesson to help you apply this theory in your own drawing of a sphere.

A sphere looks round because of the five elements of shading. It is important to learn all of these elements.

1. Cast shadow. This is the darkest dark of your drawing. It will usually be found in the shadow cast next to the object rather than on the object itself. It is where the light is completely blocked.

2. Shadow edge. This is the darkest area of the object. It is where the rounded part of the object curves away from the light.

3. Halftone. This is the neutral tone of your object where it is not in the shadow, but is not directly in the light either. It is halfway between the two.

4. Reflected light. This is always found along the edge of an object. It is the light coming from behind and bouncing off of the surrounding surfaces. It tells us that there is a back side to the object. It is most noticeable in the shadow areas where it separates the cast shadow below it from the shadow edge of the object. Without reflected light, these areas would seem to run together, making the object appear flat.

5. Full light area. This is where the light is the strongest.

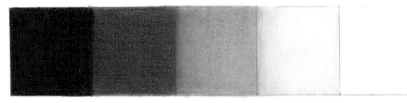

#1 Black #2 Dark Gray #3 Medium Gray #4 Light Gray #5 White

A five-box scale. Each box represents one of the five elements of shading.

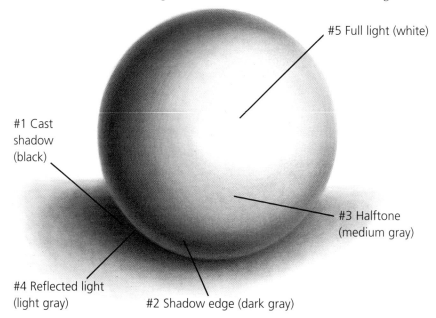

#5 Full light (white)

#1 Cast shadow (black)

#3 Halftone (medium gray)

#4 Reflected light (light gray)

#2 Shadow edge (dark gray)

Begin by tracing a perfect circle.

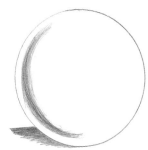

Apply your darks first, beginning with the cast shadow underneath. Place in the shadow edge, being sure to parallel the edge of the circle.

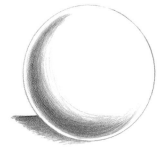

Gently start to blend with the tortillion, going "with" the shape until it fades into the full light area of the sphere.

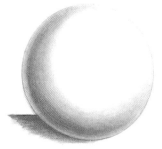

Squint your eyes and look at your drawing. If there are any imperfections, use the tricks of your tools to correct them. This is what your completed sphere should look like.

SHAPES IN ACTION

It is very important to see the underlying shape in whatever you are drawing. If you were to draw an apple, for instance, the underlying shape would be a circle. And if you were to draw a snake, the underlying shape would be a cylinder.

When drawing hands, a cylinder is one of the underlying shapes. However, since fingers are not as rounded as that, the cylindrical shapes are squared off into more of a rectangular shape.

Look at the difference between the rectangular shape and the two cylindrical shapes. Because of the rounded surface of the cylinders, the shadows continue around the object, creating what is called a "soft edge." Any rounded surface will have a soft edge, as seen in the sphere exercise on the previous page. The five elements of shading can be found there. (These examples are lacking a cast shadow since they are not sitting on something.)

The rectangle, on the other hand, is not curved. It has separate, connecting surfaces that come together to form what is called a "hard edge." A hard edge can be found anywhere two surfaces touch or overlap.

The hand has both types of edges. The fingers themselves are soft edged because of their roundness, but hard edges are formed where the fingers come together or overlap.

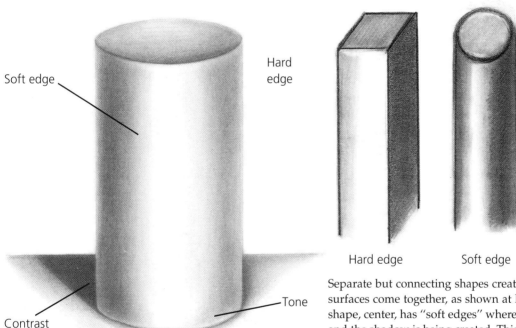

Soft edge

Hard edge

Contrast

Tone

Hard edge

Soft edge

Soft edge

The shape of the cylinder has all five elements of shading, along with both hard and soft edges.

Separate but connecting shapes create "hard edges" where surfaces come together, as shown at left. The cylindrical shape, center, has "soft edges" where the surface is rounded and the shadow is being created. This shape, however, is too rounded for the shape of the fingers. The squared version of the cylinder at right is a combination of the first two. Its more rectangular shape better resembles the fingers.

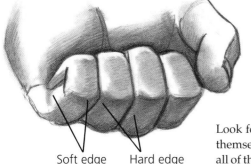

Soft edge Hard edge

Look for the soft edges in the fingers themselves and the hard edges where all of the separate surfaces are touching.

UNDERLYING SHAPES

Look at the obvious underlying shapes in these examples. It is easy to see the rectangular nature of the hand's structure. To keep the palm and fingers from appearing too flat or rounded, always remember to look for the underlying shapes.

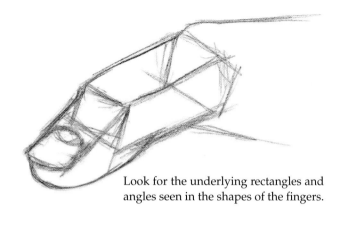

Look for the underlying rectangles and angles seen in the shapes of the fingers.

The hand is not thin and flat. Look for the dimension created by the rectangular shape. This is most obvious along the side of the hand. Notice the "block" created by the wrist.

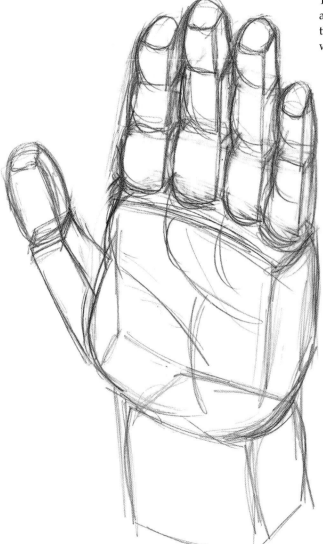

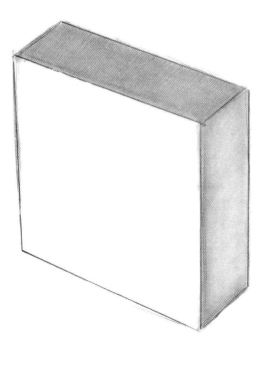

ANATOMY—BONES

It is also important to understand the anatomy of the hand before you attempt to draw it. After all, it is the bones and muscles inside the hand that give the outside its shape.

If you were a doctor, it would be important for you to learn and memorize the name of every bone, tendon and muscle of the hand, wrist and arm. However, as an artist, it is more important to know them as shapes. The name of the bone or its latin origin is not important, but the shape of the bone and how it connects to another shape is important. For that reason, I have chosen not to include all of the proper names and titles of the bones and muscles. That is something you can look up later if you want to go into it further. For now, just concentrate on what you are seeing, how it looks as a shape and how to draw that shape correctly.

It is the bones within the fingers that give them most of their shape. Because the fingers are not filled in with much flesh and fat, the bony structure is easy to see. The fingers are divided into four segments connected by joints or knuckles. Look at this skeletal illustration. Can you see why the fingers must *not* be drawn as one continuous tubular shape? The finger varies in its shape, being thick in some areas and thin in others.

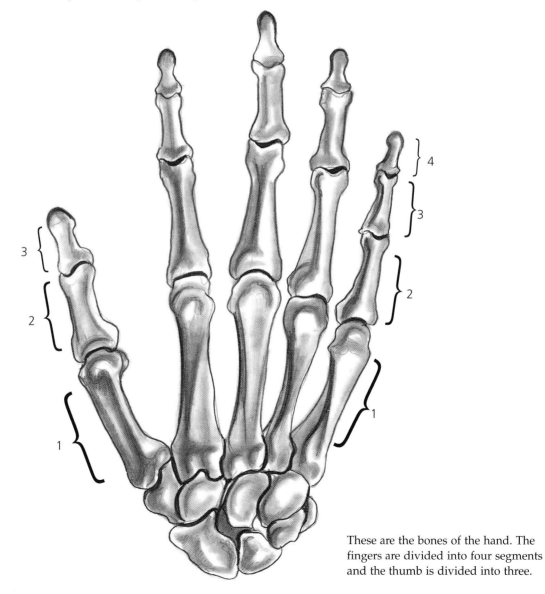

These are the bones of the hand. The fingers are divided into four segments and the thumb is divided into three.

ANATOMY—MUSCLE, TENDON

The thumb is divided into three segments, projecting off to the side more than the fingers. These shapes are changed entirely when you look at them along with the muscles and tendons connected to them.

Look at the top portion of your own hand. It is the shapes of the tendons that you see running down from your fingers to your wrist. These shapes are less obvious in babies or people that are heavier, since their hands are more filled out.

Due to the many muscles that cover the bones of the hand, the first segments of bones are covered up. If you look at the thumb area, you will see how the muscles fill in the area between the thumb and index finger, making the thumb seem shorter than it actually is.

Try to visualize these components in your own hand, seeing how the muscles and tendons create the shapes you are looking at. Remember, drawing requires you to see shapes. Just like a puzzle, all of the shapes connect to other shapes, creating a form.

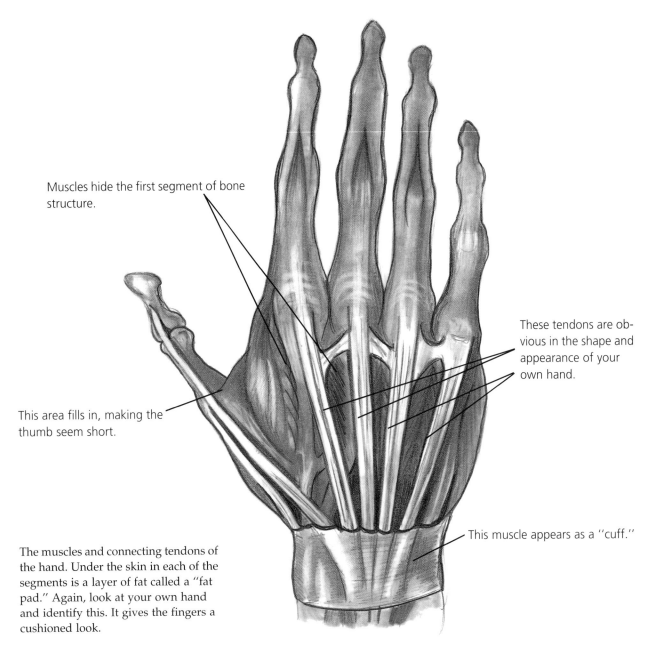

Muscles hide the first segment of bone structure.

These tendons are obvious in the shape and appearance of your own hand.

This area fills in, making the thumb seem short.

This muscle appears as a "cuff."

The muscles and connecting tendons of the hand. Under the skin in each of the segments is a layer of fat called a "fat pad." Again, look at your own hand and identify this. It gives the fingers a cushioned look.

OUTWARD APPEARANCE

We know that bones and muscles give hands their basic shapes, but it is the outer features that are seen the most. One of the most important features are the fingernails. And, like anything else, you must first study and understand them to draw them accurately.

There is a clear difference between the fingernails of a male and those of a female. Let's begin with the male study. As the illustrations show, the nail shapes appear differently according to the pose the hand is in. When viewed from various positions, all shapes change radically.

The nail is narrower at the nail root and widens as it reaches the fingertip. Look for the white "moon" shape located at the nail root, just below the cuticle. This is seen less in females if they use fingernail polish.

The nail itself is not flat. It is arched around the curve of the finger. Because of this arch, it sinks into the finger, forming what is called a nail groove. This indention then creates a raised surface on either side called a nail wall.

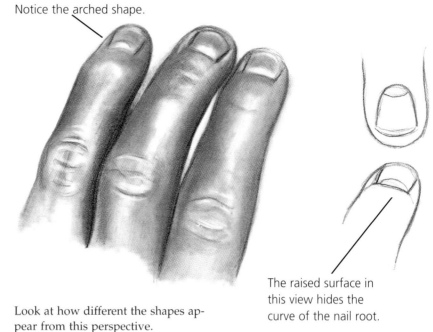

Notice the arched shape.

Look at how different the shapes appear from this perspective.

The raised surface in this view hides the curve of the nail root.

The shape of the fingernail will change according to the position your are viewing it from.

The fingernail and how it looks on a male hand.

Fat pad

Nail bed indentation or groove

Moon shape (nail root)

Nail wall

Nail wall

Light nail tip

FEMALE FINGERS

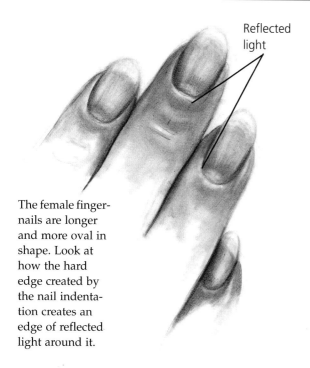

Reflected light

The female finger-
nails are longer
and more oval in
shape. Look at
how the hard
edge created by
the nail indenta-
tion creates an
edge of reflected
light around it.

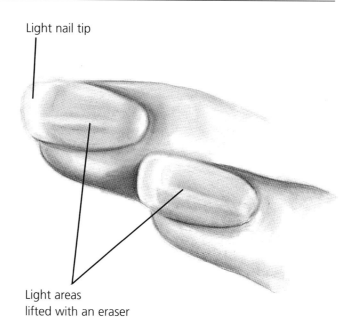

Light nail tip

Light areas
lifted with an eraser

The shininess of this fingernail study was lifted out with the kneaded eraser. The moon of the nail would not be seen if these fingernails were polished.

PROPORTION

One of the most common errors in drawing hands is drawing them too small. Size relationships are very important. No matter how well drawn something is, it will not look realistic if it is not in proportion.

I find that it is easiest to remember the size of something by comparing it with something else. To remember the size of the hand, look at your face. The measurement from the wrist bone to the top of your middle finger is the same as the length from your chin line to the top of your head. If you place your hand over your face with the palm resting on your chin, the top of your middle finger will hit around the hairline at the top of your forehead.

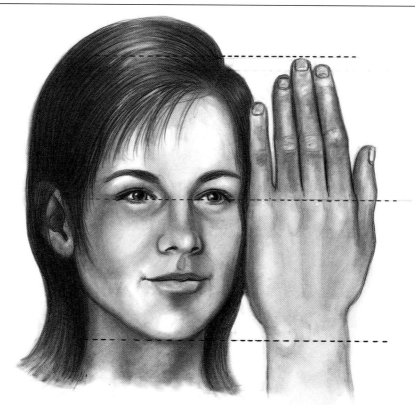

The most common error in drawing hands is making them too small in comparison to the rest of the body.

ANGLES

To keep hands from looking too rounded in your drawings, look at the angles. You have already learned that the underlying shapes of the hand are somewhat rectangular. By studying the examples on these two pages, you can see the many angles that are created by these rectangular formations. There are many more angles than you probably think. By reducing the illustrations to nothing but angles, you can see where to look for them. Look at your own hand and find some of these straight, angular surfaces.

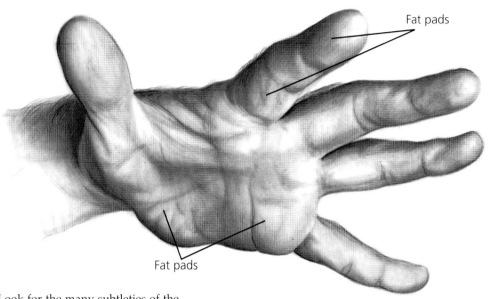

Fat pads

Fat pads

Look for the many subtleties of the hand, especially in the light and darks, creases and lines. Look at the areas that protrude more than others, such as the fat pads of the fingers and palm.

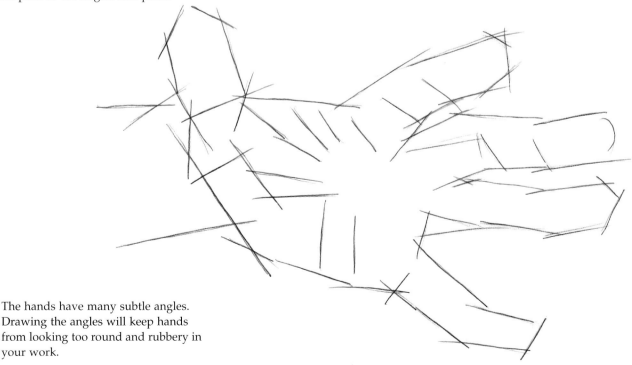

The hands have many subtle angles. Drawing the angles will keep hands from looking too round and rubbery in your work.

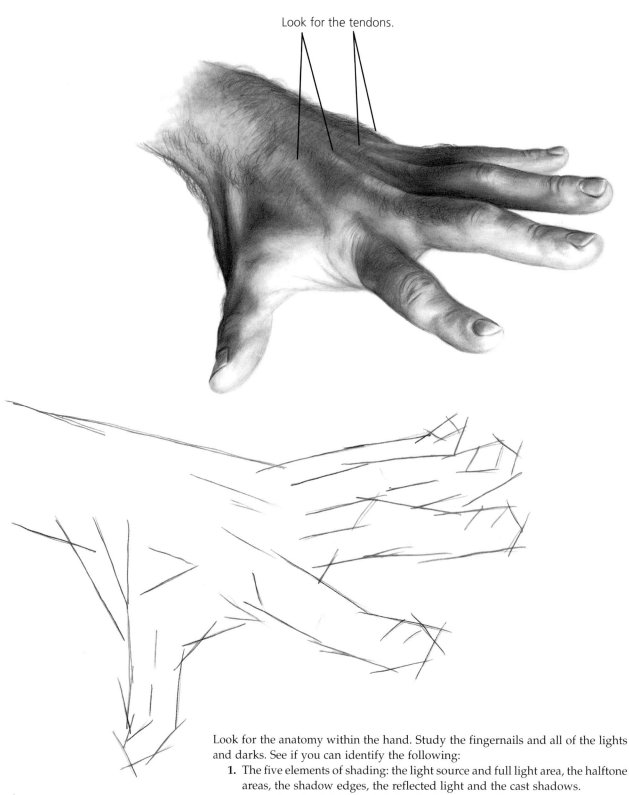

Look for the tendons.

Look for the anatomy within the hand. Study the fingernails and all of the lights and darks. See if you can identify the following:

1. The five elements of shading: the light source and full light area, the halftone areas, the shadow edges, the reflected light and the cast shadows.
2. Where has the light been lifted out with an eraser?
3. Where are the soft edges?
4. Where are the hard edges?
5. Where are the tendons showing?
6. Where is the bone structure showing?

HOW TO FORESHORTEN

Usually when we remember what something looks like, we recall the pose that shows us most of the object. For instance, when asked what a face looks like, we automatically recall the entire face as if we were looking straight at it rather than at its profile.

The same is true of hands. We recall the entire hand, flat and out-stretched. But in nature, objects are often moving, and we see them from various angles. This forces us to see three-dimensional objects in perspective.

Observe the poses of the hand on the next two pages. Notice how different viewpoints affect the way you see the shapes, especially in the areas that protrude, such as the fingers.

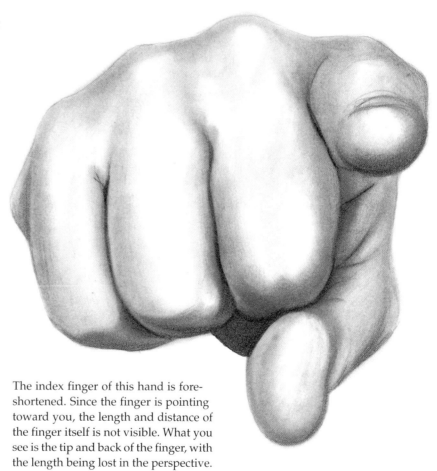

The index finger of this hand is fore-shortened. Since the finger is pointing toward you, the length and distance of the finger itself is not visible. What you see is the tip and back of the finger, with the length being lost in the perspective.

PERSPECTIVE

When drawing hands, foreshortening is the most crucial element to accurately capture. Without it, the hand will not look right. If the fingers are drawn with too much length, the perspective of coming forward or pointing away will be lost.

At this angle, the full length of the index finger is visible.

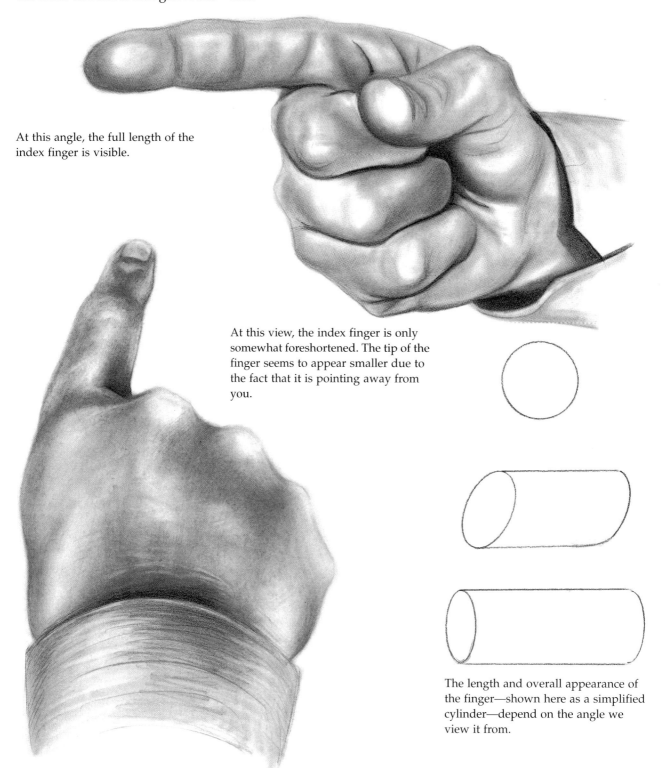

At this view, the index finger is only somewhat foreshortened. The tip of the finger seems to appear smaller due to the fact that it is pointing away from you.

The length and overall appearance of the finger—shown here as a simplified cylinder—depend on the angle we view it from.

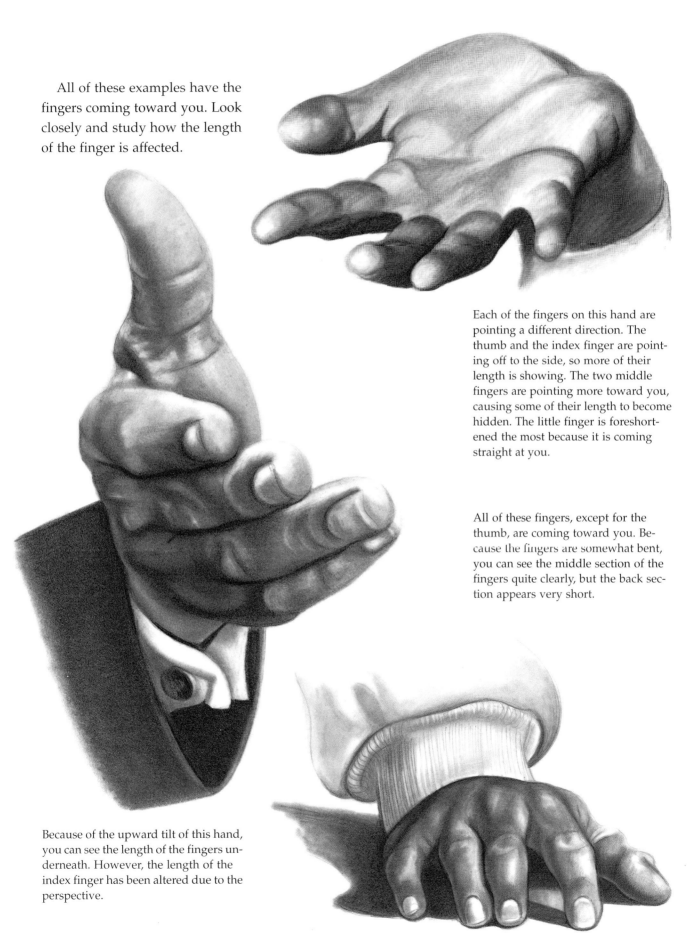

All of these examples have the fingers coming toward you. Look closely and study how the length of the finger is affected.

Each of the fingers on this hand are pointing a different direction. The thumb and the index finger are pointing off to the side, so more of their length is showing. The two middle fingers are pointing more toward you, causing some of their length to become hidden. The little finger is foreshortened the most because it is coming straight at you.

All of these fingers, except for the thumb, are coming toward you. Because the fingers are somewhat bent, you can see the middle section of the fingers quite clearly, but the back section appears very short.

Because of the upward tilt of this hand, you can see the length of the fingers underneath. However, the length of the index finger has been altered due to the perspective.

GETTING STARTED

It is now time to take the information that has been presented to you and put it into practice. You have been shown that breaking your subject into small, puzzle-like shapes can help you with accuracy. You have also been shown how foreshortening affects the shapes of the hand, making some areas seem to get smaller and even to disappear altogether.

Begin by drawing some foreshortened hands, using the graphs for guides. At this stage, I want you to concentrate on just shapes, not blending and shading. That will come later. For now, study how all of the shapes fit together. Look for angles that are created by the bones and knuckles. Look at how the lights and darks create shapes themselves.

Begin by lightly drawing a graph on your paper with your pencil. Use a good ruler, and be sure to make your boxes perfectly straight and square. If you want to make your drawing the same size as mine, use the same-sized boxes. You can also enlarge the size of the drawing by using larger boxes as long as the boxes are perfectly square. One box at a time, draw the shapes you see inside the boxes until you have the drawing finished like mine. Later on you can come back to these line drawings and add the shading for practice.

This picture has the index finger coming straight at you. Look at how short the finger appears to be.

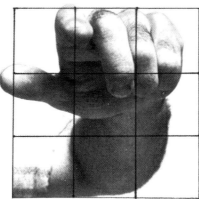

Rather than draw on top of the photograph, I had a black-and-white laser print made of the photo. Notice how the grid helps with the placement of shapes by showing where they fall within the borders of each box.

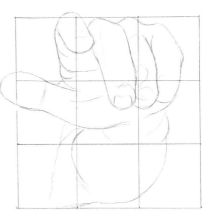

This is my line drawing. Study it to see how I drew the shapes, especially the light and dark shapes seen on the fingers.

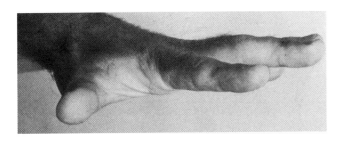

The fingers are easy to see due to the outstretched position, but look for the foreshortening in the thumb.

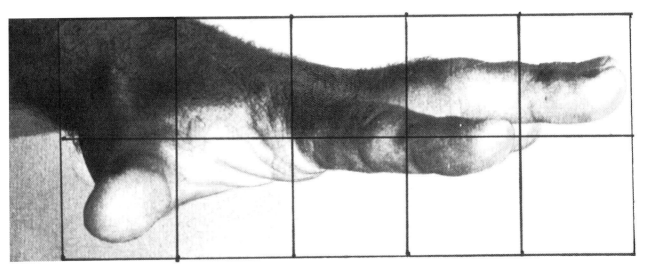

Enlarging the photo makes it easier to draw. Drawing something large is always easier than drawing it small.

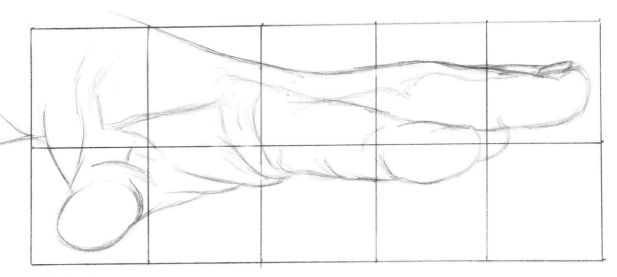

An accurate line drawing.

CHAPTER SIX

BABIES' AND CHILDREN'S HANDS

As with everything in nature, age and its effects alter the way things look. Hands are no exception. Much can be told about a person's age by looking at their hands.

Youthful hands are much smoother and rounder than those of an adult. Also, the differences between male and female hands are not noticeable at a young age. Because of this, I have chosen to present children's hands first, and then show you how things change as we get older.

Babies have the cutest hands due to their chubby, rounded appearance. The examples on the next three pages show these characteristics well. Look for all of the things that make these hands seem young. Take the wrists, for example. Because of the proportion of body fat at this age, there is always a definite crease where the hand attaches to the wrist. It seems almost doll-like, as if the hand could be screwed off and on.

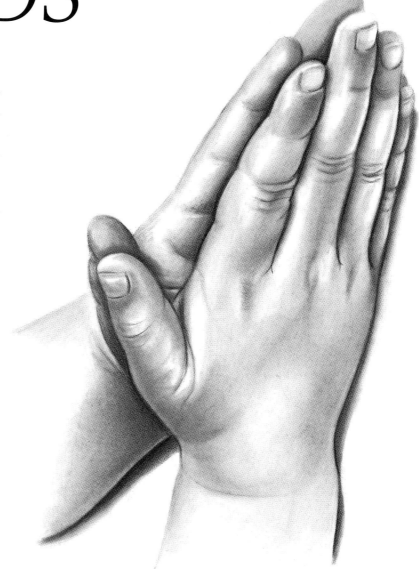

Praying Hands
11″ × 14″ (28cm × 36cm)
Graphite on smooth bristol board.

Notice the fingers and their roundness. This makes a baby's fingers appear almost pointy at the ends, unlike an adult's. On the palm side of the hand, the creases seem much deeper and more pronounced, whereas the knuckle area on the other side is much less lined than an adult's hand.

Although the light source causes dark areas and shadows, the skin of a baby or young person is always lighter and smoother than a grown-up's. This is where a very gradual, smooth blend with your pencil and tortillion will be essential to your drawing. Practice your value scales, and be sure that you can smoothly blend from dark to the white of the paper before you attempt to capture the smoothness of a baby's hand.

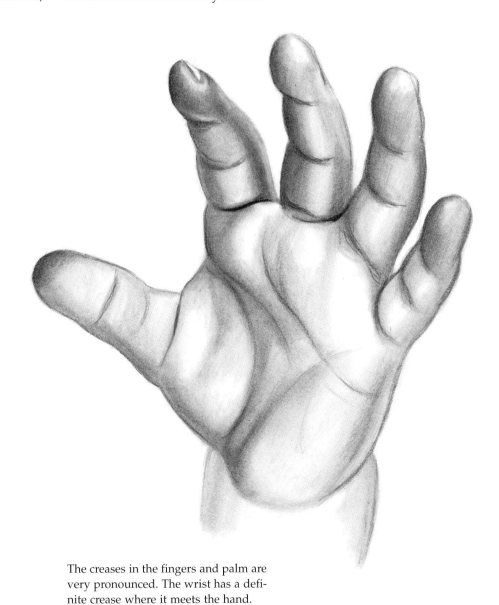

The creases in the fingers and palm are very pronounced. The wrist has a definite crease where it meets the hand.

STUDYING POSES AND LIGHTING

Remember that practice is the key to your drawing success. It will be helpful for you to draw hands in as many different poses and lighting situations as possible. Start collecting references from magazines and photographs for your practice work.

Later in the book, we will be drawing hands step-by-step together. For now I want you to *visually* study the illustrations, paying attention to the shapes and characteristics. Later, after you have learned the step-by-step process for drawing hands, it will be helpful to come back to this chapter to draw these hands for practice.

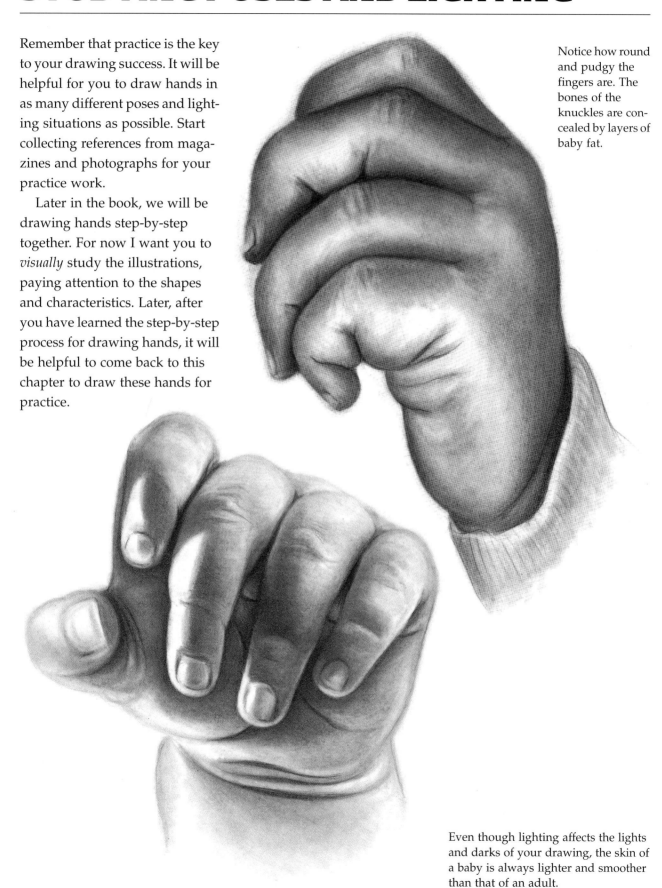

Notice how round and pudgy the fingers are. The bones of the knuckles are concealed by layers of baby fat.

Even though lighting affects the lights and darks of your drawing, the skin of a baby is always lighter and smoother than that of an adult.

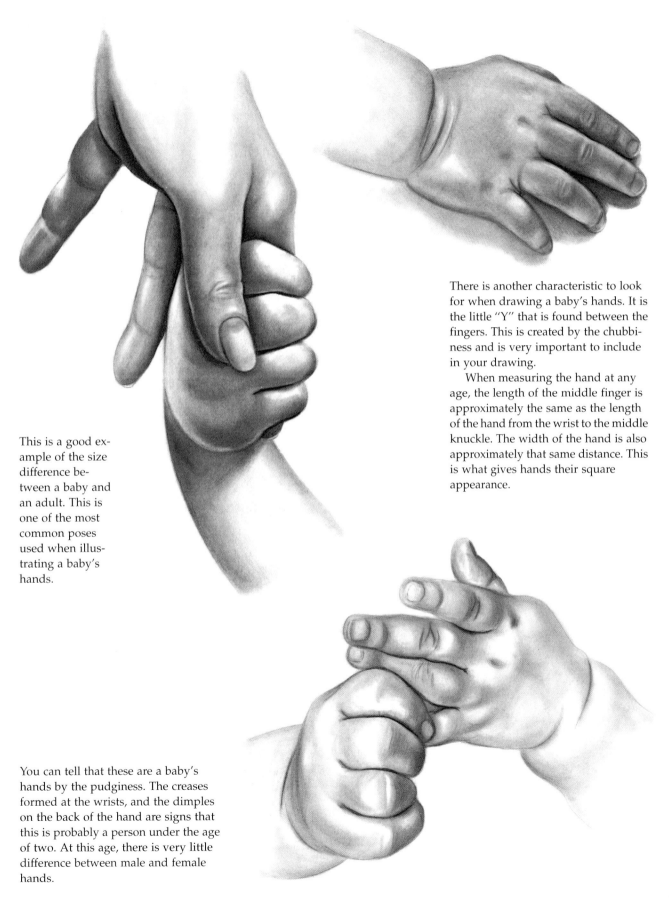

This is a good example of the size difference between a baby and an adult. This is one of the most common poses used when illustrating a baby's hands.

There is another characteristic to look for when drawing a baby's hands. It is the little "Y" that is found between the fingers. This is created by the chubbiness and is very important to include in your drawing.

When measuring the hand at any age, the length of the middle finger is approximately the same as the length of the hand from the wrist to the middle knuckle. The width of the hand is also approximately that same distance. This is what gives hands their square appearance.

You can tell that these are a baby's hands by the pudginess. The creases formed at the wrists, and the dimples on the back of the hand are signs that this is probably a person under the age of two. At this age, there is very little difference between male and female hands.

CHILDREN'S HANDS

As a child grows, the hands become leaner and less pudgy. Although the bone structure is becoming more evident, many of the characteristics of an adult hand are still missing, such as veins, hair and bone shadows. The skin remains smooth and light up until the preteen years.

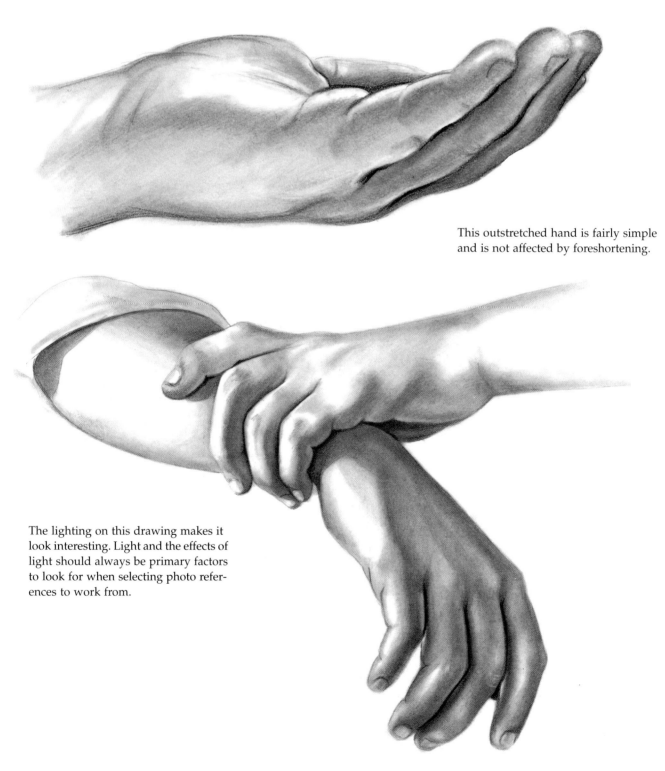

This outstretched hand is fairly simple and is not affected by foreshortening.

The lighting on this drawing makes it look interesting. Light and the effects of light should always be primary factors to look for when selecting photo references to work from.

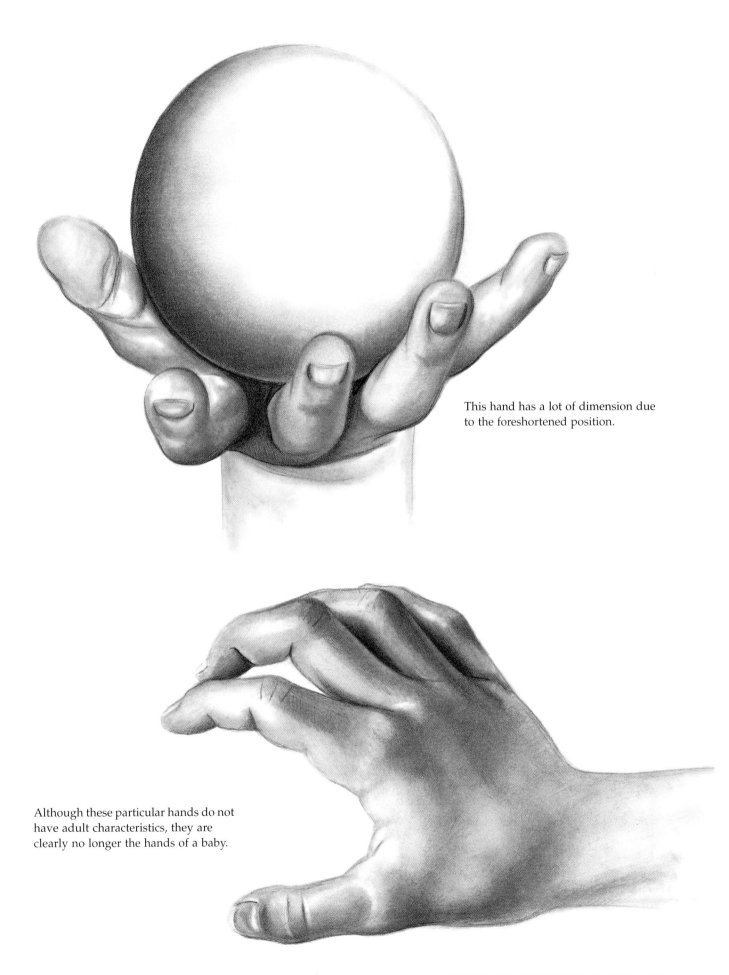

This hand has a lot of dimension due to the foreshortened position.

Although these particular hands do not have adult characteristics, they are clearly no longer the hands of a baby.

CHAPTER SEVEN

DRAWING FEMALE HANDS

You have seen how hands vary according to age. I chose to present the female hand next because it shares some of the characteristics of young hands.

As adults, our hands thin out, losing some of the puffiness they had when we were children. This makes the bone structure more apparent, along with the veins. The older we get, the more noticeable this becomes. Only when someone is overweight does this rule not apply. Extra weight will fill out the hand, making it retain the roundness seen as a child.

Study the illustrations, comparing them with the children's hands in the previous chapter. Can you see how the bone structure is more obvious? The knuckles and the creases on the knuckles are more defined. The proportions are still the same, with the length of the middle finger being equal to the length of the hand from the wrist to the middle knuckle.

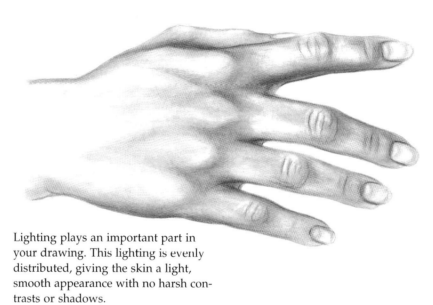

Lighting plays an important part in your drawing. This lighting is evenly distributed, giving the skin a light, smooth appearance with no harsh contrasts or shadows.

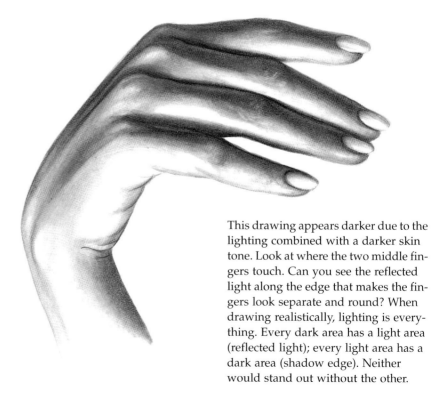

This drawing appears darker due to the lighting combined with a darker skin tone. Look at where the two middle fingers touch. Can you see the reflected light along the edge that makes the fingers look separate and round? When drawing realistically, lighting is everything. Every dark area has a light area (reflected light); every light area has a dark area (shadow edge). Neither would stand out without the other.

FEMALE VS. MALE

Compare the female hand to that of a male. Can you see how much thinner and more tapered the female hand is? The male hand is much more square and boxy. Also, the lack of dark body hair makes the female hand appear more smooth.

When compared with the hands of a male, the skin of the female is usually lighter and smoother, much like a child's. What makes women's hands different from both children's and men's hands are their shape. The female hand is more tapered and less boxy than the male's. The fingertips are pointier and the fingers themselves, as well as the hand, are not as thick. If the fingernails have been grown out, this will add to the slender appearance.

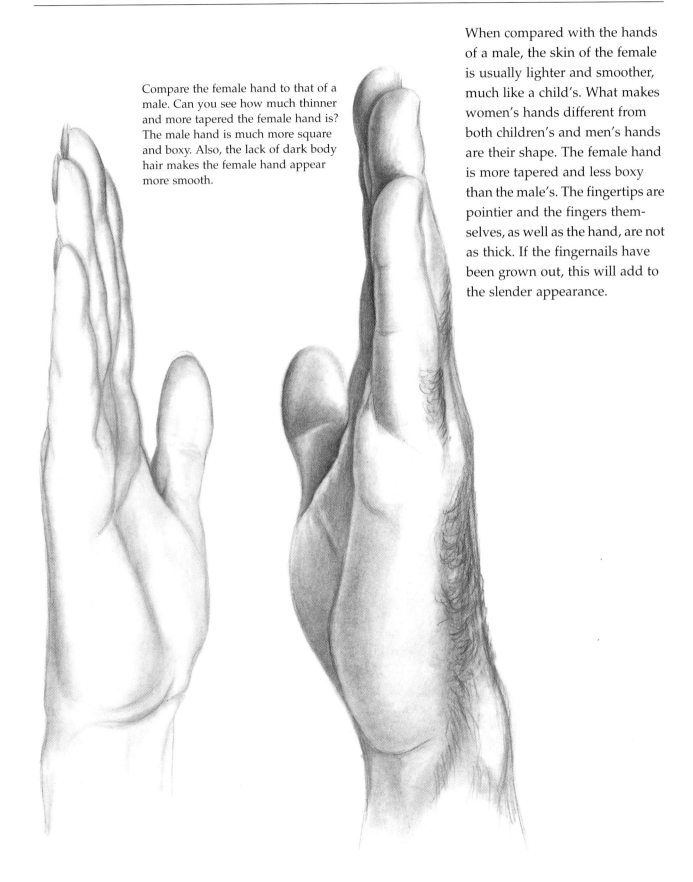

STUDYING WOMEN'S HANDS

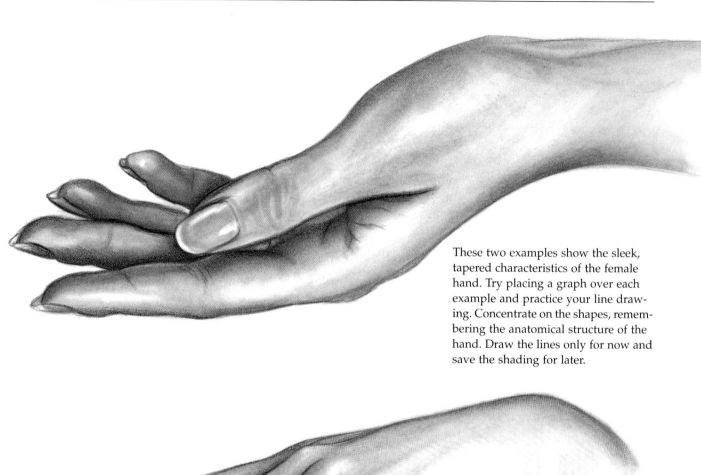

These two examples show the sleek, tapered characteristics of the female hand. Try placing a graph over each example and practice your line drawing. Concentrate on the shapes, remembering the anatomical structure of the hand. Draw the lines only for now and save the shading for later.

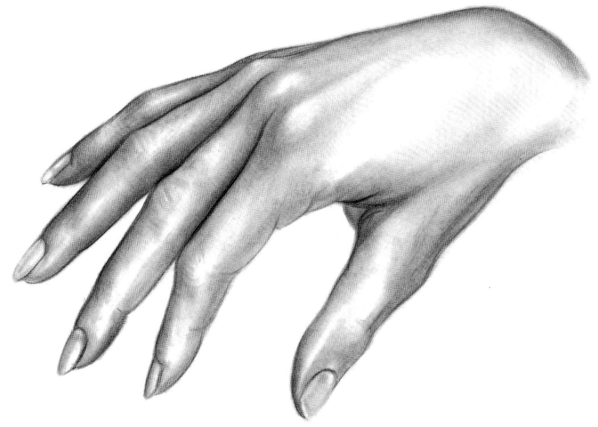

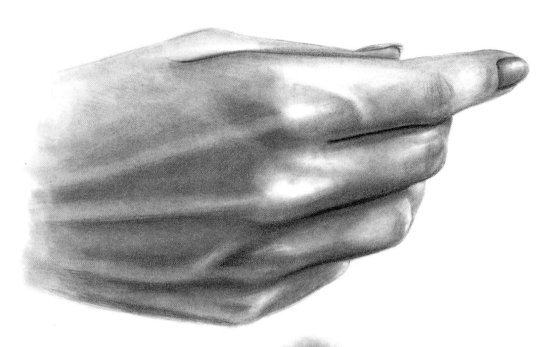

This hand illustrates the bony structure and veins that begin to show as we get older. Notice how the areas that protrude are lighter than the rest of the hand.

By placing some shading in the background of this drawing, the light edges of the hand can be seen more clearly. This also reduces the need for dark edges, which if not done properly, could look like an outline.

DRAWING WOMEN'S HANDS

You are now ready to draw entire hands using my step-by-step process for smooth blending and realism. The following pages will give you practice drawing the female hand. Once you have completed the exercises and feel confident with your skills, go back to the line drawings from the previous chapter and use your blending and shading to finish them.

When you first begin drawing, drawing an entire hand can seem pretty overwhelming. You can make it simpler if you draw just part of the hand. The "viewfinder" is a method I developed to help my students in the classroom. It does not just apply to hand drawing; it can be used for any subject matter.

You should now be fairly familiar with the graph or grid method. The viewfinder is similar in theory, but it helps you draw freehand. Rather than using a graph over the entire photo, isolate a *portion* of a photograph with a viewfinder. The result is called a "segment drawing."

To make a viewfinder, simply cut an opening in a black piece of paper. This one I used here was four-inches square with a two-inch square cut out of the middle. You can make it any size or shape you want.

Next, place it over the photo reference you are working from to isolate an area of the photo that will be easier to draw. By looking at how the shapes are framed by

the viewfinder, you can re-create them on your drawing paper. Lightly draw the same square on your paper, and then draw what are called "positive" and "negative" shapes. Positive shapes are the shapes of the fingers themselves, while negative shapes are those created by the background or empty spaces.

Try to see the hand within the viewfinder not as a hand, but as a group of puzzle piece shapes all connected together. Look closely at where they are placed within the square. If this is a difficult concept for you, feel free to add a grid over it and use your graphing techniques to obtain an accurate line drawing.

A photo reference with a viewfinder placed over it.

The shapes seen within the viewfinder. Look at them as puzzle piece shapes. The fingers are positive shapes, and the black background areas are negative shapes.

Begin by lightly drawing the square. Look at the shapes within the square and lightly sketch them in, being careful to study their size and placement.

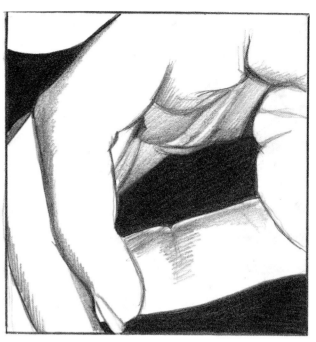

Darken in the negative shapes.

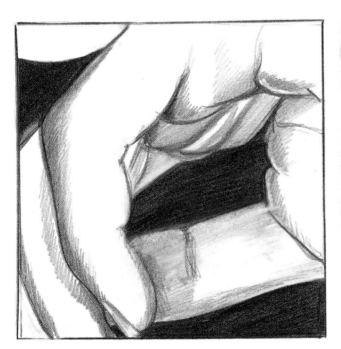

Study where the dark areas of the fingers are and gently place in some tone with your pencil.

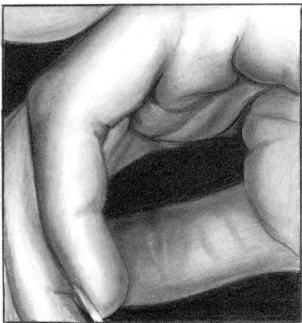

With your tortillion, softly blend the tones from dark to light.

WHOLE HAND, STEP BY STEP

Let's draw the whole hand step-by-step, adding blending and shading for a finished rendering.

Begin by studying the photo. Then study the placement of shapes within each box of the graph. Look for the positive shapes (the hand and fingers) and the negative shapes (the background). Make an accurate line drawing at this stage. Never begin adding tone to a drawing until you are sure that none of the shapes will have to be altered or changed. It is very hard to correct shapes that have been filled in with tone. This is what your line drawing should look like at this stage.

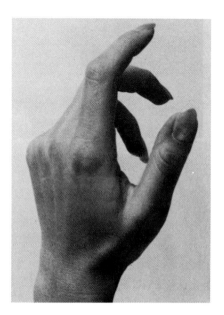

Look for the light source in this photo. See how the front of the hand is lighter and the back of the fingers are darkened by shadows?

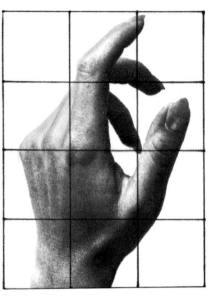

Placing a graph over a photo helps you to see and draw the shapes more accurately.

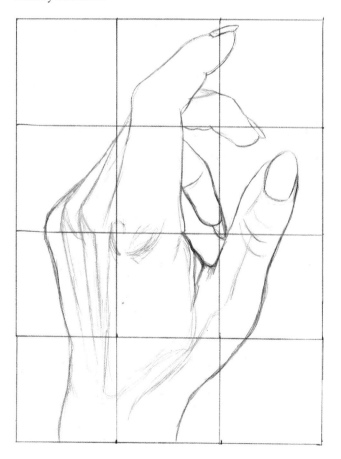

Look for the positive and negative shapes. Be sure that your line drawing is accurate before you continue with the blending and shading.

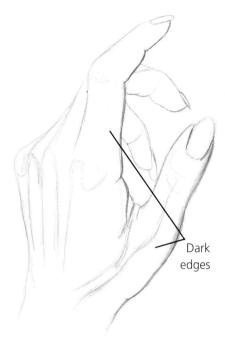

Dark
edges

◄ Remove the graph from your drawing with the kneaded eraser, leaving behind your accurate line drawing. Look at the original photo. The right edges of the thumb and index finger are extremely dark. Darken these areas on your line drawing first.

Begin placing tone in the darkest areas of the fingers. Fill them in smoothly, using evenly applied pencil lines. ▶

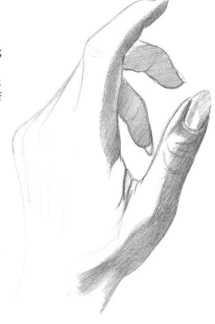

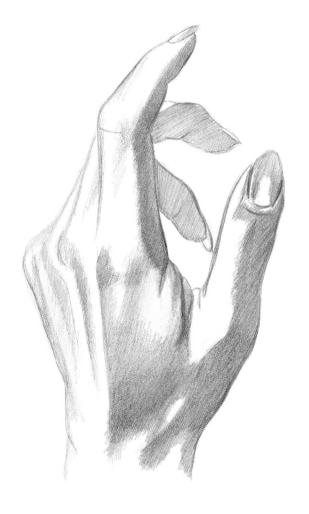

This is a dark edge because the finger behind it is light in this area.

Reflected light

Continue adding tones. This time apply the midtones, paying special attention to the shapes that those tones are creating.

Gently blend the tones together with a tortillion. Pay close attention to the edges of the fingers that have reflected light.

TECHNIQUE REVIEW

As you can probably see, I use the same procedure whenever I am drawing with graphite. And the same rules apply to all subject matter. The step-by-step process is as follows:

1. Complete an accurate line drawing of your subject, seeing it not as what it *is*, but as a group of shapes.

2. Study the object and identify all of the areas of light and dark. Look for the light source; notice how all of the full light areas and shadows create shapes on the object. Look for all five elements of shading, especially the shadow edges and reflected light. Also, look for areas that are light against dark and dark against light.

3. Smoothly apply your tones with your pencil, beginning with the darkest areas first.

4. Smoothly apply the half-tones with your pencil.

5. Gently blend the tones together with a tortillion. When the tones are smooth and even, reapply the darker areas. Also, lift any highlights or other light details with the kneaded eraser.

Practice this pose by placing a graph over the first drawing and using it to draw your accurate line drawing. When the shapes are correct, begin placing tones. Blend your work to achieve the look of the second drawing.

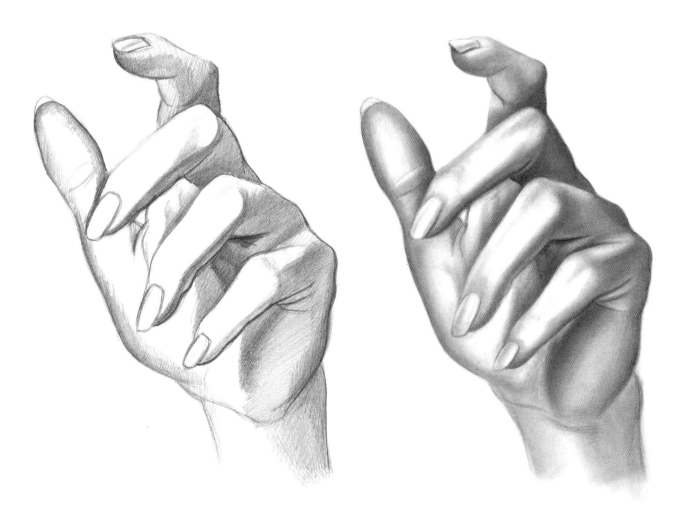

This drawing is halfway finished. To use for practice work, place one of your graphs over it and draw an accurate line drawing. When you are sure that you have everything drawn correctly, begin to place your tones as you see them here. Again, look for shadow edges and areas of reflected light.

Use a tortillion to gently blend out the tones. Strengthen the dark areas again if they fade with the blending, and lighten to full light areas with your kneaded eraser.

CHAPTER EIGHT

DRAWING MALE HANDS

We have already established the fact that the male hand is boxier in form than the female hand. But there are other characteristics of the male hand that we have not covered. If you look closely at this drawing, you will see body hair. Most people never think of drawing it even if they see it in the reference, but I think it is very important to include for realism. You will see it on the knuckles, the hand and the arm. In this chapter, I will show you how to draw hair and other features of men's hands.

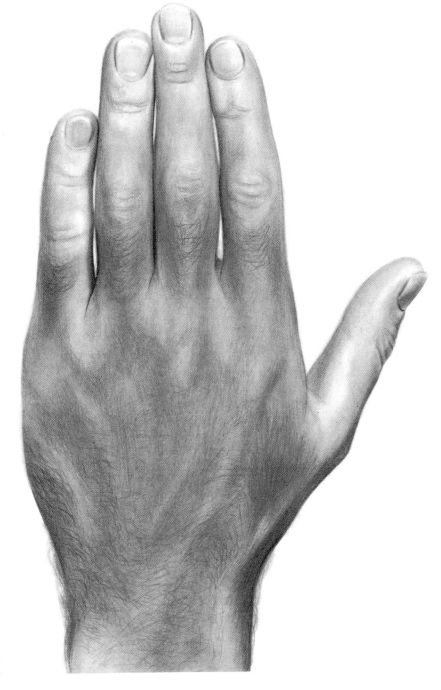

Look at all of the small hairs on this example. They can be seen on the knuckle areas, the hand and the arm.

MALE VS. FEMALE

Before we move on, let's take a look at the differences between male and female hands one more time. In this comparison drawing, you can see many differences between the two. Start with the thumbs. The man's thumb is clearly larger and squarer than the female's. Even the thumbnail is boxier. Due to the muscle formation, the overall shape of the male hand is much more square, especially in the area above the thumb where the hand meets the wrist.

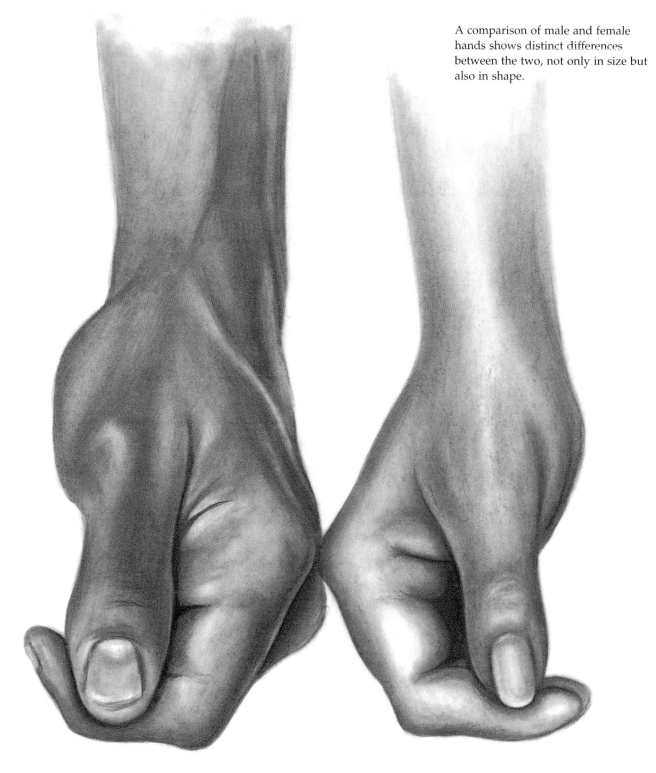

A comparison of male and female hands shows distinct differences between the two, not only in size but also in shape.

USING LIGHT

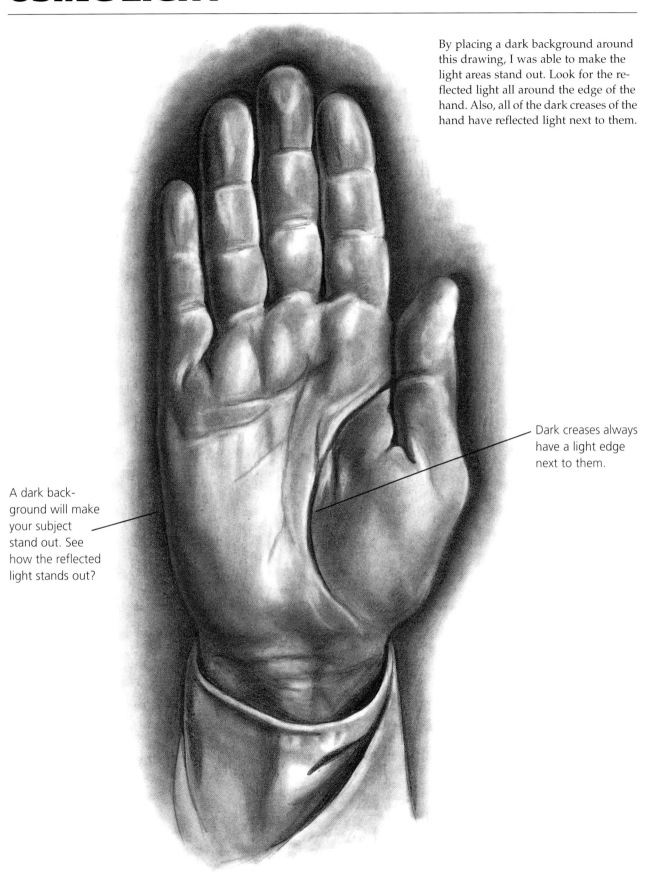

By placing a dark background around this drawing, I was able to make the light areas stand out. Look for the reflected light all around the edge of the hand. Also, all of the dark creases of the hand have reflected light next to them.

Dark creases always have a light edge next to them.

A dark background will make your subject stand out. See how the reflected light stands out?

DRAWING A FIST

Drawing a fist can be a fun way to draw the hand. It eliminates the challenge of drawing each finger, and turns the hand into a more unified shape. Each one of these poses offers a different challenge for you, with different things to look for in each.

This angle shows the rectangular nature of the fingers and thumb. I like this pose due to the extreme dark areas under the fingers. They give the pose a lot of depth.

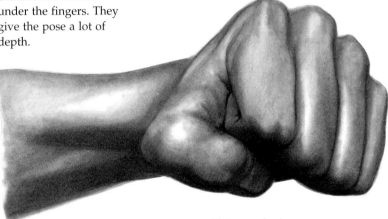

This pose looks very square. The fingers curve under like a shelf.

Look at the boxy nature of this pose.

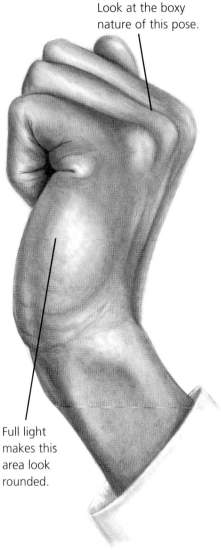

Full light makes this area look rounded.

This pose shows the fleshy side of the hand. See how the full light makes it look round?

Pay attention to how the arm connects to the hand at the wrist.

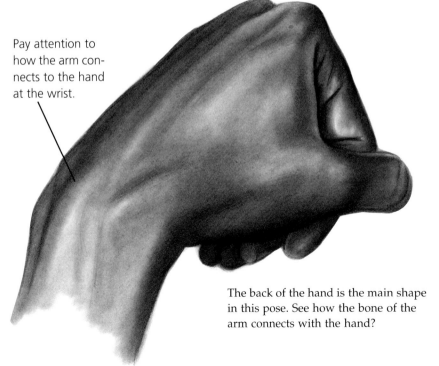

The back of the hand is the main shape in this pose. See how the bone of the arm connects with the hand?

OTHER POSES TO STUDY

Here are some more examples. Observe each one carefully, looking for unique characteristics. Look not only for shape and anatomy, but also for the techniques used to achieve the look of the drawings. Try to see where hard edges are being created. Which areas gently curve and create soft edges instead? Where are the five elements of shading?

This is a somewhat casual pose, but due to the light source, watch for the shadows. See how the shadow of the fingers cross along the inside of the palm of the hand?

Look for cast shadows like this for realism.

Look for overlapping surfaces and place shadows accordingly.

The light areas are pulled out with a kneaded eraser.

This is a fun one to draw. Be sure to include the creases under the thumb and the shadows under the finger.

This shows many of the hand's veins. Because of the light, the veins have shadows next to them on the left side.

ADDING HAIR

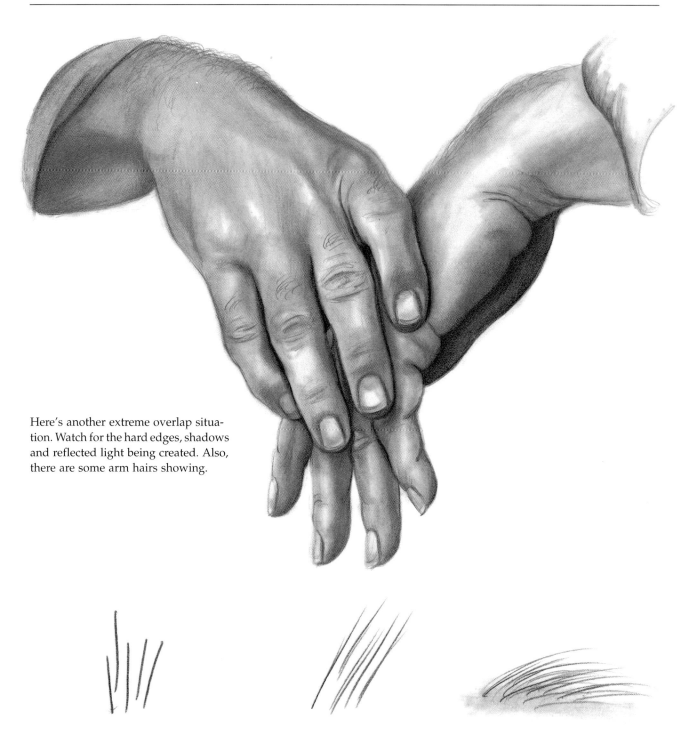

Here's another extreme overlap situation. Watch for the hard edges, shadows and reflected light being created. Also, there are some arm hairs showing.

To draw body hair, *never* use hard deliberate lines such as these.

A quick flick of the pencil will give you a nicer, more tapered line, which will look more like that of hair.

Follow the hair's growth pattern when applying the quick, tapered pencil lines. Be sure that you have blended the skin tone underneath first. Make sure that the hair lines are overlapping, creating layers.

MALE HANDS, STEP BY STEP

The following pages will give you more step-by-step exercises to work from. I also encourage you to practice drawing from the illustrations in this book. This can be done by making a graph overlay. With a permanent black marker and ruler, draw a graph of 1-inch (25mm) squares on a clear report cover or piece of acetate. (I also like to make one with ½-inch (12mm) squares.) By placing the overlay on top of the illustrations in this book, you can grid them like the step-by-step exercises. All you need to do is draw what you see in each box on a lightly drawn graph on your drawing paper. Don't forget to use the viewfinder to draw a segment drawing from any of the illustrations in this book. The more you practice, the better you will get at this technique.

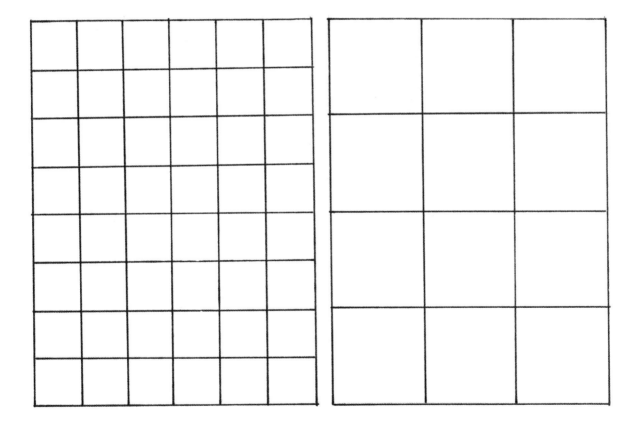

A SIMPLE POSE

Here is a simple pose to practice from. It is fairly straightforward, but there is some foreshortening above the wrist where the hand projects toward you.

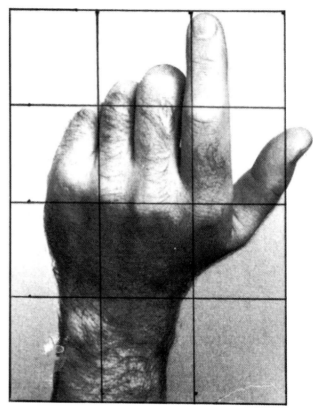

When drawing from photographs, I often have an enlargement made. It helps me to see the shapes more clearly. However the details of the shading are easier to see in the original photo.

Look closely to see how I drew the shapes within each of the boxes. See if you can get your drawing to look like mine. When drawing the graph on your paper, be sure that you use extremely light pencil lines. Once you are sure that your line drawing is accurate, remove the graph lines with your kneaded eraser.

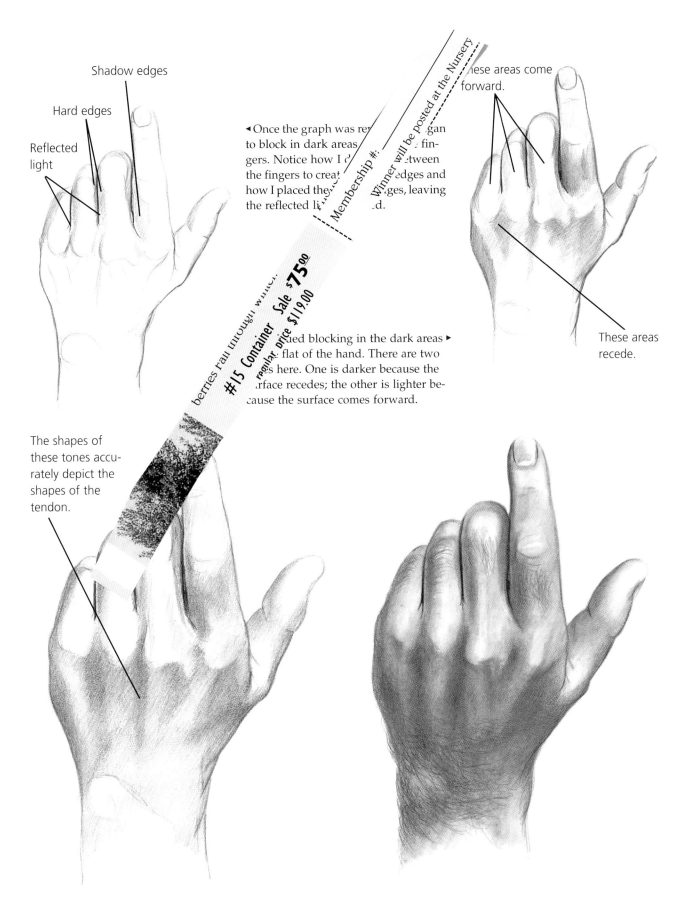

Shadow edges

Hard edges

Reflected
light

These areas come
forward.

These areas
recede.

The shapes of
these tones accu-
rately depict the
shapes of the
tendon.

◄ Once the graph was re— —gan
to block in dark areas, — fin-
gers. Notice how I d— —tween
the fingers to creat— —edges and
how I placed the — —ges, leaving
the reflected li— —d.

—ued blocking in the dark areas ►
— flat of the hand. There are two
—s here. One is darker because the
—rface recedes; the other is lighter be-
cause the surface comes forward.

I completed adding values until I had all of the tones filled
in. I paid particular attention to the shapes that the tones
were creating, being sure that they were accurately illustrat-
ing the anatomy being represented.

With a tortillion, I blended the tones together. I made sure
that the tones were smooth and gradual. As a final touch, I
added the body hair with quick, tapered pencil strokes, being
sure to follow the hair's growth pattern.

THE BACK OF THE HAND

Before you begin this step-by-step exercise, study the basic shape of this hand. Notice how square it is. Also, because you are looking at the back of the hand, you can plainly see all of the hairs on the hand and the arm. Begin by lightly drawing a graph on your drawing paper.

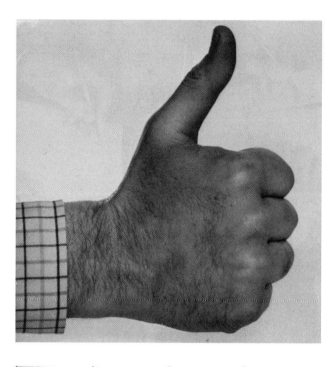

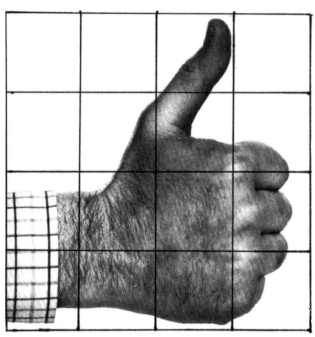

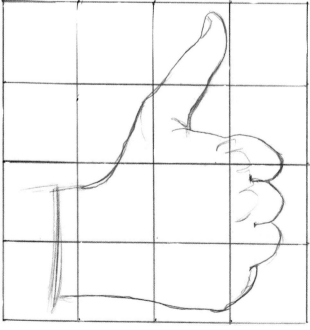

Draw as accurately as possible until your drawing looks like mine.

Once your drawing is accurate, remove your graph lines.

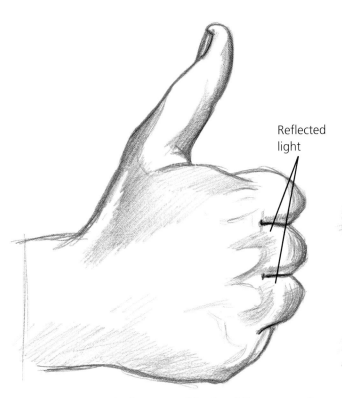

Reflected
light

Darken between the fingers, and begin adding tone to the darkest areas of shadow. See how the reflected light is already becoming evident?

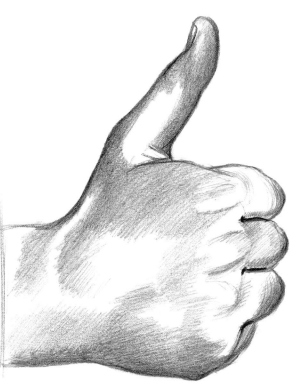

Continue adding dark areas. Be careful about the shapes created by the tones.

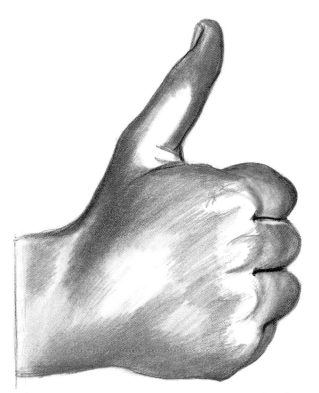

Blend the tones with the tortillion. Do not lose the shapes that are creating the anatomy. Watch for the light areas that protrude, such as the knuckles and the thumb. If these areas get too dark, lift more light out with the kneaded eraser.

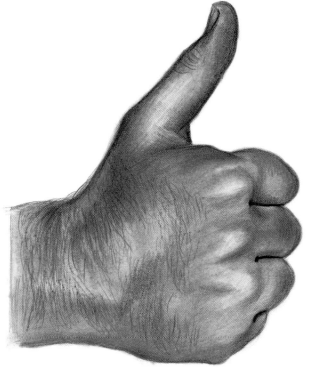

Continue blending until you reach the desired tone in your work. Once again, squinting your eyes will help you see the tones better to compare them with your photo reference. As a last detail, add the body hair for realism.

THE INSIDE OF THE HAND

Let's try the same pose from a different view. Now, instead of the back of the hand, you can see the fingers and all of the angles and hard edges they create. Pay particular attention to the shapes of the fingernails. Study the many shapes closely before you begin to draw.

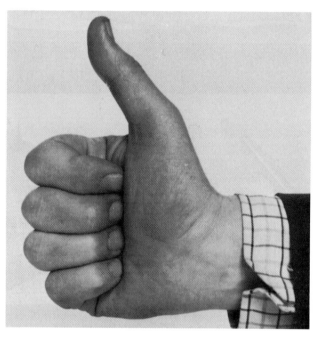

I made this drawing the same size as the photograph.

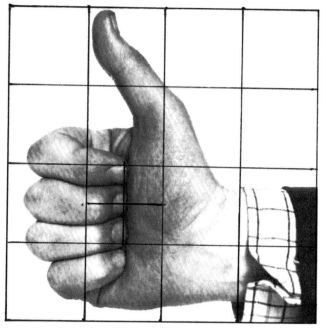

I used 1-inch (25mm) squares for the graph.

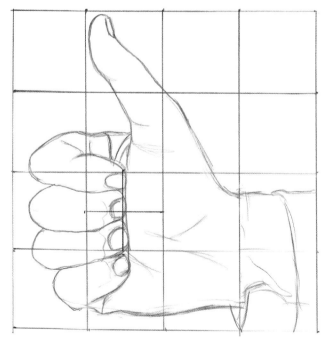

Be careful to study the placement of all the shapes within the boxes, especially the ones that contain the fingernails. If it helps, you can subdivide the box into ½-inch (12mm) increments to further guide you with the shapes. Smaller boxes give you less room for error.

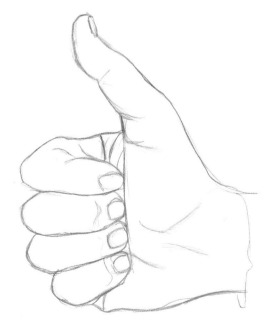

An accurate line drawing with the graph lines removed.

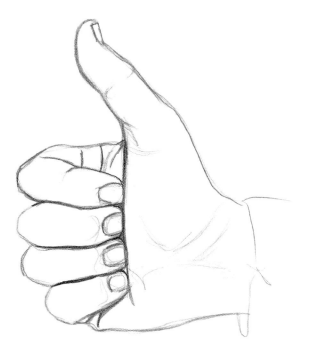

Strengthen the hard edges with your pencil.

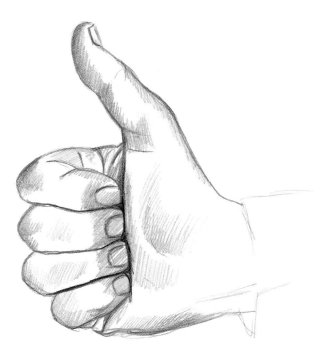

Begin placing your tones, being careful to keep them in their proper shape.

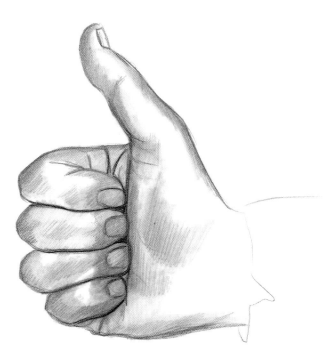

Continue placing the tones to further describe the shape of the anatomy.

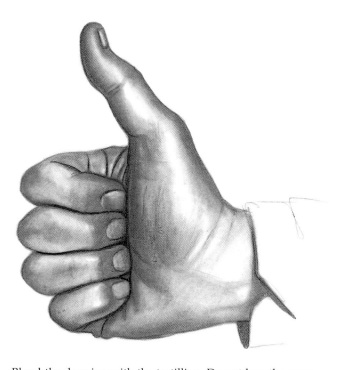

Blend the drawing with the tortillion. Do not lose the areas of reflected light. Gently lighten with a kneaded eraser if necessary.

AN OUTSTRETCHED HAND

To truly understand the hand, it is important to draw them in as many poses as possible. This outstretched position will give you a challenge. For further practice, look through magazines and books for other poses to practice from.

On a pose such as this one, it is important to pay attention to the spaces between the fingers. Draw both the positive shapes, which is the hand itself, and the negative shapes, which is all of the area surrounding it. By treating the empty spaces as shapes, it is easier to obtain an accurate drawing with realistic proportions.

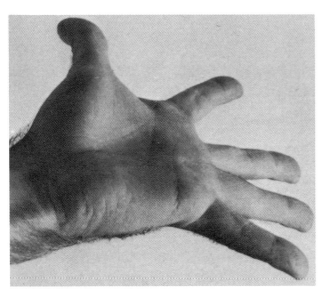

A pose to challenge you.

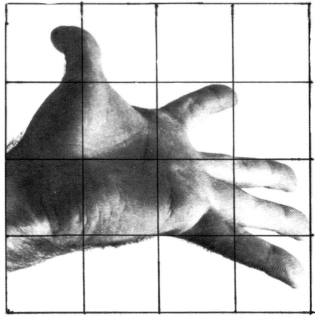

I enlarged this one to make it easier to draw.

The hand is a positive shape.

The areas between the fingers are negative shapes.

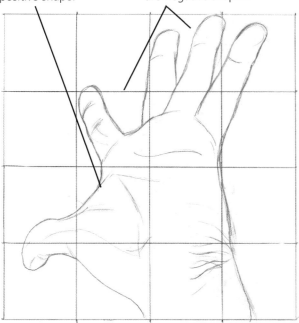

Pay attention to the positive and negative spaces and shapes.

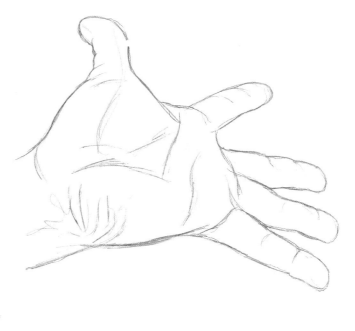

An accurate line drawing with the graph lines removed.

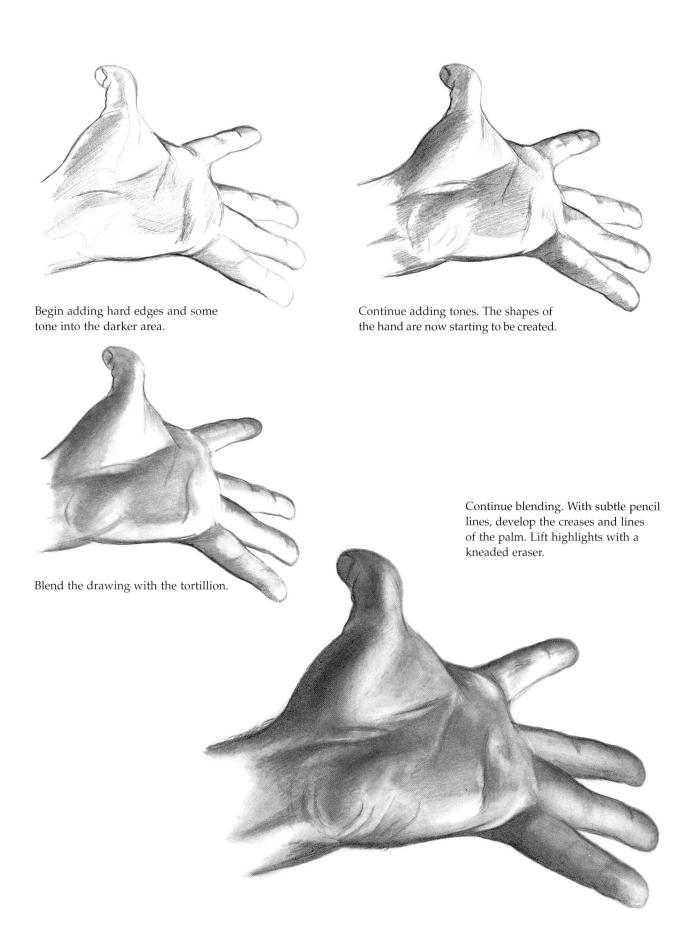

Begin adding hard edges and some tone into the darker area.

Continue adding tones. The shapes of the hand are now starting to be created.

Blend the drawing with the tortillion.

Continue blending. With subtle pencil lines, develop the creases and lines of the palm. Lift highlights with a kneaded eraser.

HANDS FOR YOU TO DRAW

For additional practice, I have given you these examples to work from. Each photo gives you a different pose to study with the graphed example next to it. Also, a line drawing has been drawn within a graph for you to repli-cate. Try to be as accurate as possible, so that your line drawing looks like mine. Review the procedures for blending and shading, and try to render these drawings on your own.

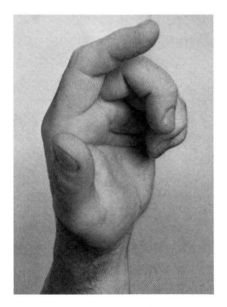

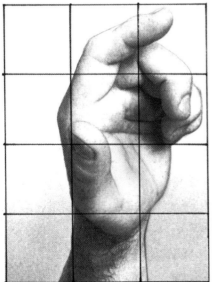

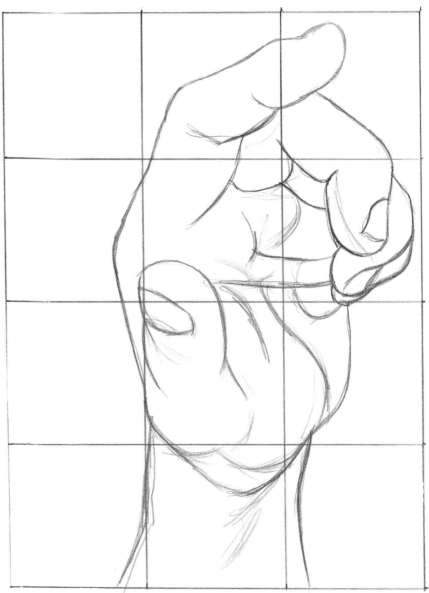

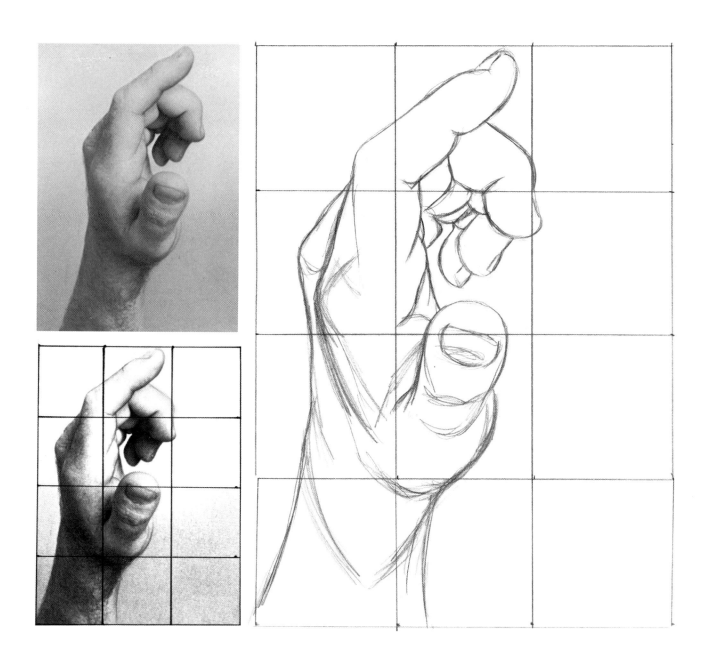

MORE PRACTICE HANDS

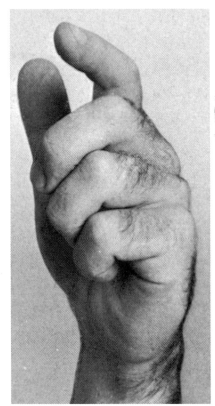

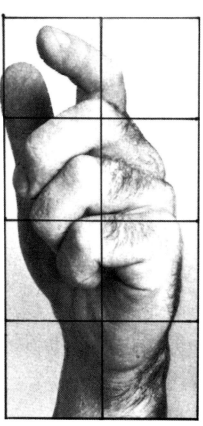

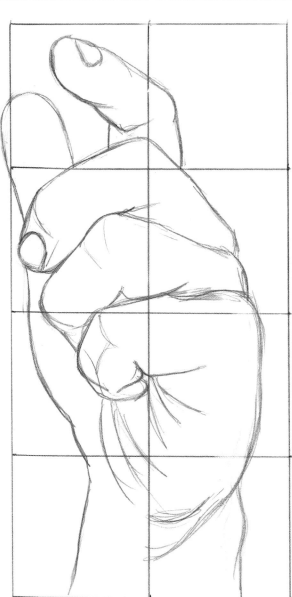

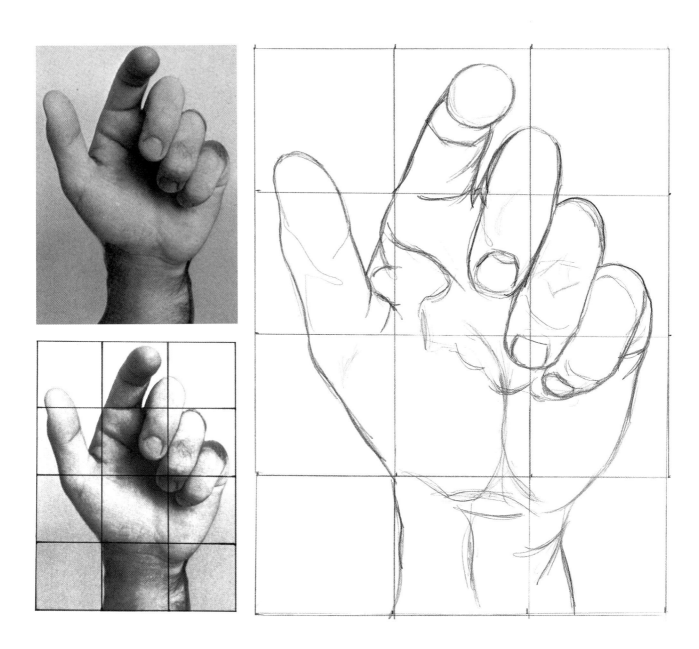

AGE AND CHARACTER

Like anything affected by age, hands take on many characteristics as they become older. I love to draw older people because of the deep character seen in their faces. I love to draw their hands for the same reason. Hands change as we grow older, giving them a more interesting, unusual look. Some of the things to look for in older hands are:

- Enlarged, more obvious veins
- More pronounced bone and knuckle structure
- Age spots on the skin
- Wrinkled skin and deeper creases

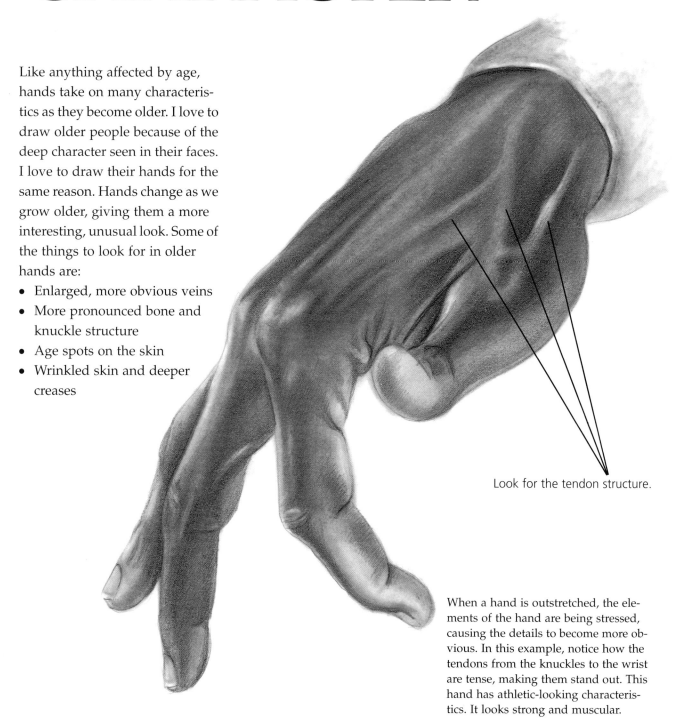

Look for the tendon structure.

When a hand is outstretched, the elements of the hand are being stressed, causing the details to become more obvious. In this example, notice how the tendons from the knuckles to the wrist are tense, making them stand out. This hand has athletic-looking characteristics. It looks strong and muscular.

These hands are obviously older as seen in their character lines. Study them closely for their structure, shape and anatomy, then look at them again for their artistic quality and technique.

All of these where drawn using the same procedure as before, but after the blending was completed, the veins, wrinkles and creases were accentuated. Both the darks and the lights were strengthened to make these old age characteristics stand out.

It is important to remember that every raised surface, such as a vein or tendon, that reflects light will have a shadow area next to it, making it stand out. Also, every dark wrinkle or crease will have reflected light on the edge.

A shadow under the hand will give the impression that it is resting on a surface. It will also help you see the reflected light on the edge of the fingers. This is what makes the fingers seem dimensional.

This shadow makes the reflected light on the edge of the finger stand out.

The veins of this hand give it character. The relaxed pose gives it a smoothness that does not expose the tendons, like a flexed or stressed pose would. Take note of the extreme blending that went into the skin tone.

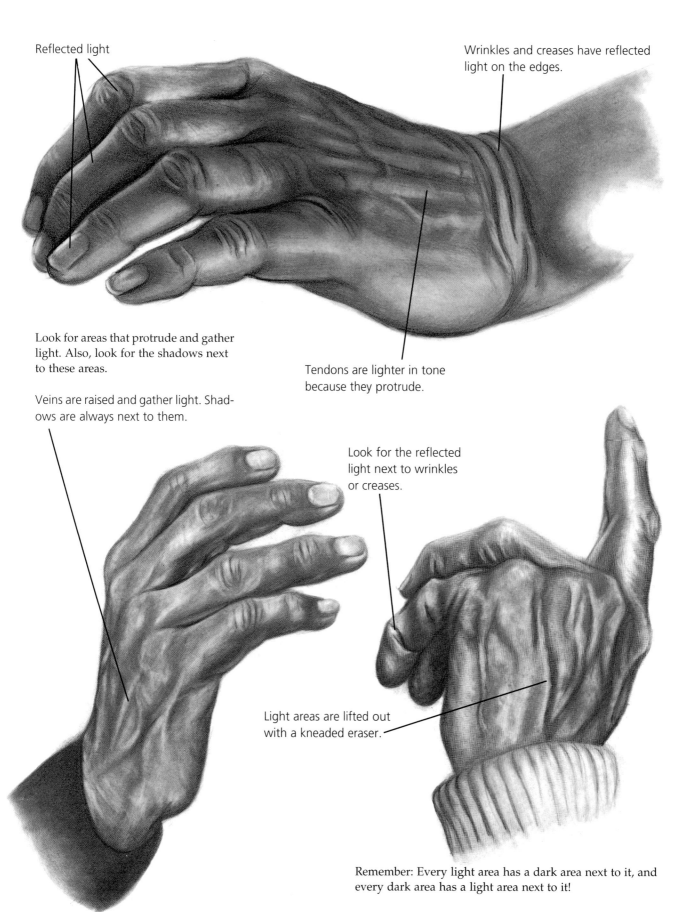

Reflected light

Wrinkles and creases have reflected light on the edges.

Look for areas that protrude and gather light. Also, look for the shadows next to these areas.

Veins are raised and gather light. Shadows are always next to them.

Tendons are lighter in tone because they protrude.

Look for the reflected light next to wrinkles or creases.

Light areas are lifted out with a kneaded eraser.

Remember: Every light area has a dark area next to it, and every dark area has a light area next to it!

CHAPTER TEN
ADDING PROPS

Although it is easier to study the hand by itself, hands are usually doing something or holding onto an object. Once you are more familiar with hands and more comfortable with your drawing skills, it is important to try drawing hands while they are holding things.

Practice drawing these illustrations by placing one of your graphs over them and following the techniques you have learned.

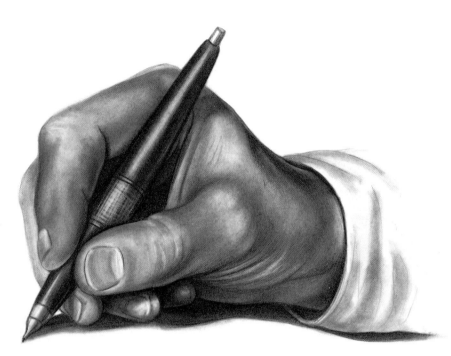

Hands holding Lee's favorite pencil! This is the most common pose for hands, since writing is one of the things we do the most with them.

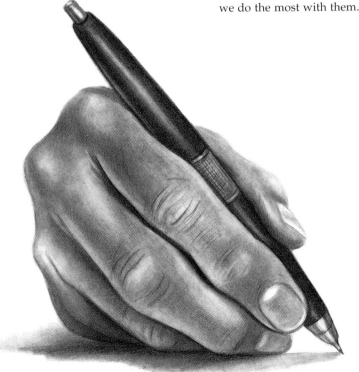

HANDS IN ACTION

Going through magazines will give you ample sources for practice material. I collect reference pictures, and now have an entire bin of just hands. Any time I need to draw a hand in a certain position, there is no doubt that I can find a reference for it in my collection. Start your own reference file of pictures. It is fun to have several categories for any type of artwork or drawing practice you may want to do.

These examples give you the opportunity to see the very complex drawing techniques within simple, everyday poses.

When things are elevated, they produce shadows below them. Look at the shadows created by these hands (here and below right). The knife, too, is casting shadows onto the surface below it. Be sure to look at these shadows as shapes when you draw them.

Shadows help create realism.

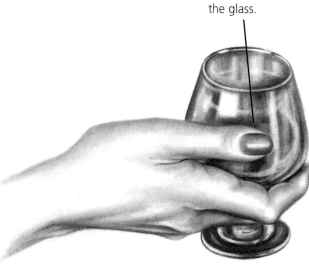

The shininess of the thumbnail resembles the shiny, smooth surface of the glass.

The strong patterns of lights and darks on the glassware contrast sharply against the smooth, even tone of the skin.

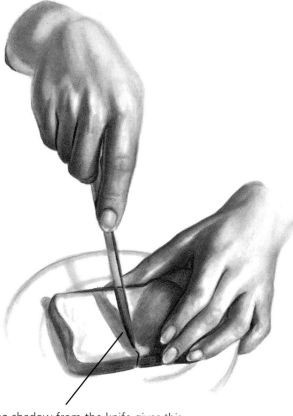

The shadow from the knife gives this drawing a lot of dimension.

Sports illustration is one of my favorite subjects. It is an exciting challenge due to the action being portrayed. The poses create sharp contrasts with many strong areas of light and dark.

Sports magazines are wonderful sources to draw from. Usually the lighting is extreme and the poses show a lot of action and movement. This gives the artwork a lot of visual impact. However, it is not important to draw the entire scene unless you really want to. Just a portion, or even a segment drawing created with a viewfinder, can be great practice and a beautiful piece of artwork.

Drawing a basketball will give you some practice with blending. The large, continuous form must be blended very smoothly, and the tones must be dark enough to convince us that it really is a basketball. Notice how the dark ridges encompassing the ball have reflected the light against them? Remember: Anything with an edge will reflect light, and anything dark will have light next to it. The full light area was lightened with the kneaded eraser to make it appear as if it was reflecting off of the surface.

The dark color of the football makes the shapes of the hands stand out in contrast. Again, look at the ball itself. The edge of the crease is surrounded by light. Also, look at the edges of the fingers. Can you see the reflected light that makes them look dimensional?

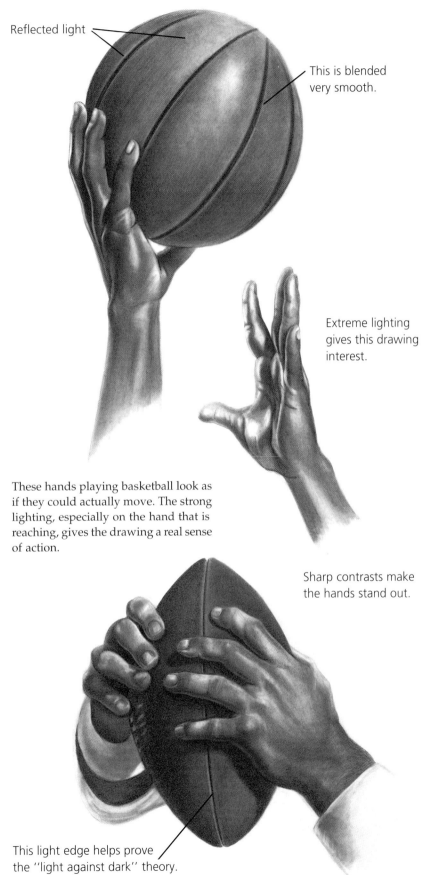

Reflected light

This is blended very smooth.

Extreme lighting gives this drawing interest.

These hands playing basketball look as if they could actually move. The strong lighting, especially on the hand that is reaching, gives the drawing a real sense of action.

Sharp contrasts make the hands stand out.

This light edge helps prove the ''light against dark'' theory.

ATHLETIC HANDS

To give the impression of strength, I chose to draw these hands along with the forearm. Although I am only drawing a portion of the entire picture, this drawing very much tells a story.

Although the hand closest to the base of the bat is wearing a batter's glove, you can still clearly see the form of the hand underneath. Notice the square, boxy shape of the hand and the rectangular forms of the fingers.

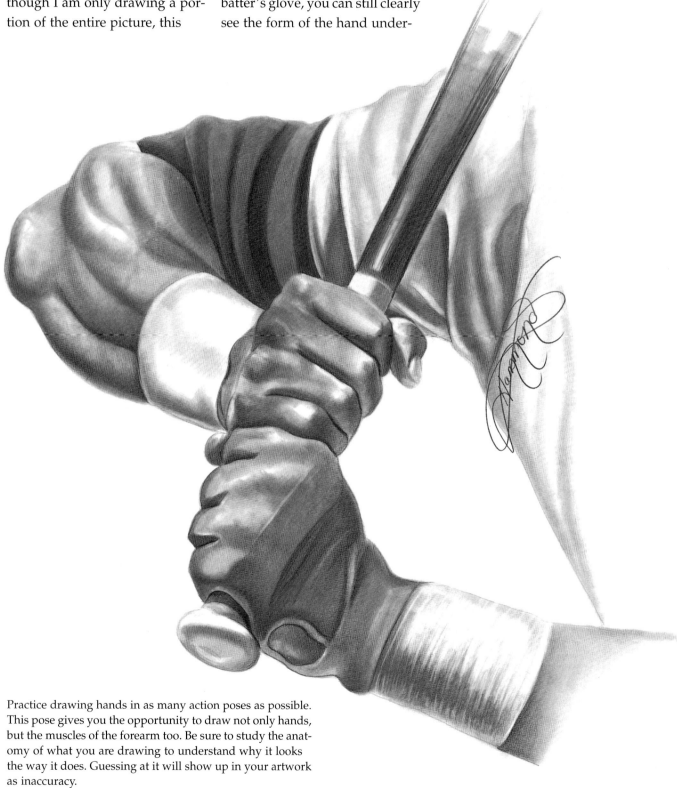

Practice drawing hands in as many action poses as possible. This pose gives you the opportunity to draw not only hands, but the muscles of the forearm too. Be sure to study the anatomy of what you are drawing to understand why it looks the way it does. Guessing at it will show up in your artwork as inaccuracy.

TELLING A STORY WITH HANDS

Hands often tell a story. What can say more than a drawing like this? It is very important to arrange your artwork in a pleasing, bal-anced fashion on your paper. The following examples will help you create a nice composition with your work.

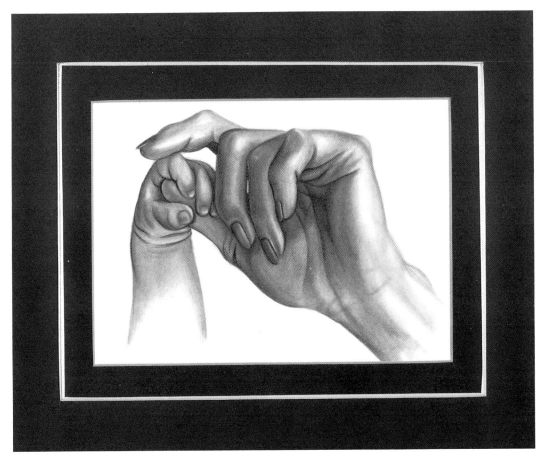

By placing this drawing into a mat, it balances the positive and negative spaces around the art-work, which keeps it from looking like it is floating. There is the same amount of weight given to the negative space, which is the background, and the positive space, which is the hands.

HANDS THAT ARE CENTER STAGE

In good artwork, composition is everything. It keeps the subjects from looking as if they are floating freely on the page. But what can you do to prevent this when you are drawing isolated subject matter that does not run off the page?

In the drawing on the previous page of the mother holding her baby's hand, I chose to put a mat around it. The mat comes in close to the drawing, eliminating the excess white paper around it. This balances it by giving it an equal amount of background to offset the subject matter.

In this example, I have created a natural framework with the shading. Here, the border becomes part of the drawing and contains the subject within a rectangular shape. By darkening the edges and corners of the piece, it leads your eye into the center of the drawing. The darkness behind the subject helps the light areas stand out. The result is a simple, yet interesting drawing and composition.

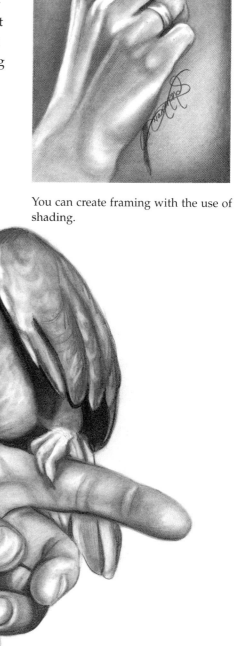

You can create framing with the use of shading.

Have some fun when drawing hands. In this particular drawing, see how the "weight" of the hand is balanced by the "weight" of the bird. This drawing would look good in a picture frame.

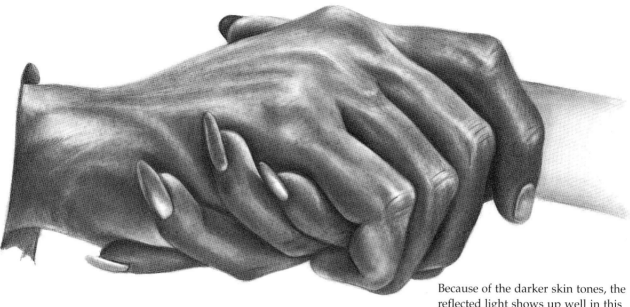

Because of the darker skin tones, the reflected light shows up well in this drawing. Look for the highlight areas that have been lifted with a kneaded eraser.

The first drawing here is a common pose, but the second drawing has an interesting, almost heart-shaped composition.

These drawings are examples of extreme overlapping of shapes. Remember that any time you have two things touching or overlapping, you will create a hard edge. And any time you create a hard edge between two surfaces, you need to add reflected light. Study these drawings for those elements.

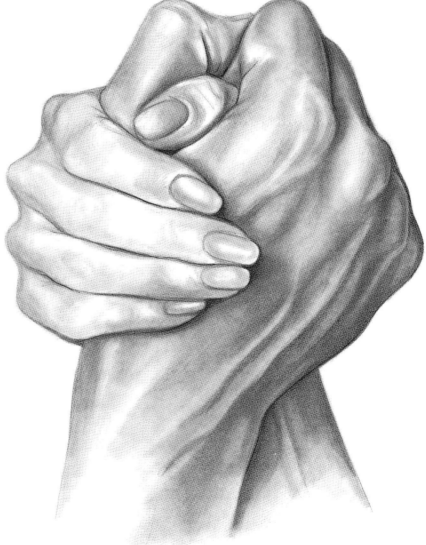

Look for the five elements of shading in this drawing. See how the shadows under the woman's fingers make them appear to be truly on top of (touching) the surface of the other hand? See how the veins of the man's hands and the highlights in the woman's fingernails, have been lifted out with a kneaded eraser?

HANDS THAT ARE PART OF A STORY

The following examples are much more complex than the ones we have seen before. This shows how important hands are any time people are included in a composition: Hands help tell the story. Imagine how these pieces of artwork would look if I had chosen to leave the hands out! This is often what happens when the artist is not proficient at drawing hands. Think of how they are limiting themselves, and the beautiful pieces of art that are not being created.

The shading behind the baby gives the drawing solidity, while the subject matter itself portrays the look of softness. By including the hand on the baby's head, it tells a story of tenderness and love. If the hand were left out, the story would be different.

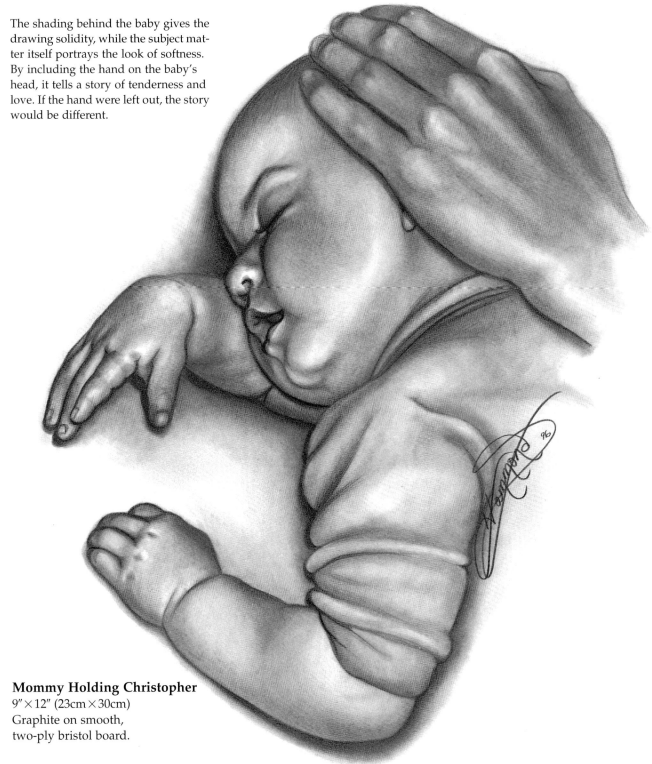

Mommy Holding Christopher
9″ × 12″ (23cm × 30cm)
Graphite on smooth,
two-ply bristol board.

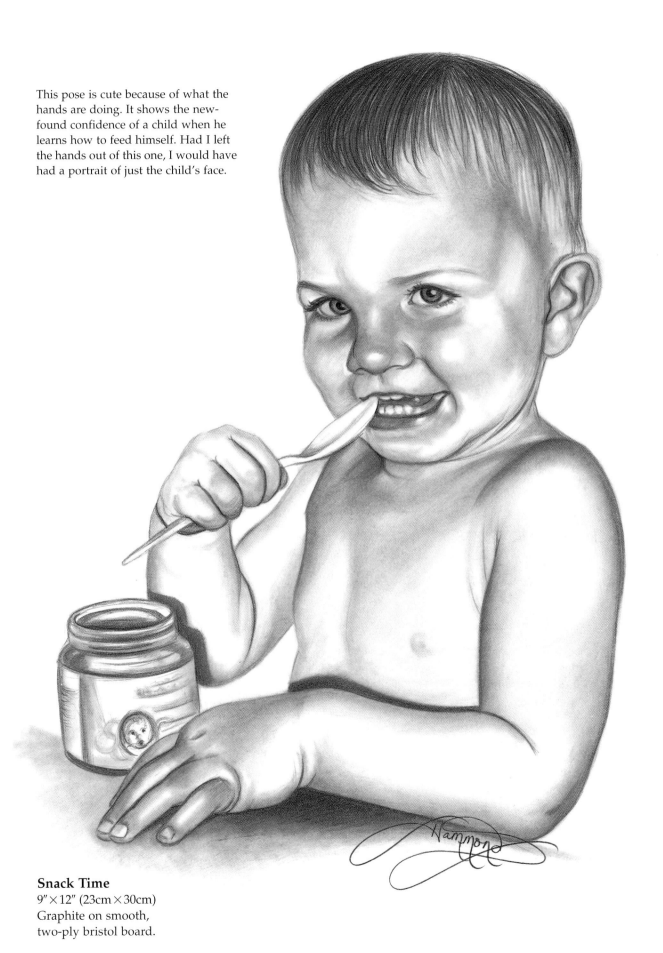

This pose is cute because of what the hands are doing. It shows the new-found confidence of a child when he learns how to feed himself. Had I left the hands out of this one, I would have had a portrait of just the child's face.

Snack Time
9″×12″ (23cm×30cm)
Graphite on smooth,
two-ply bristol board.

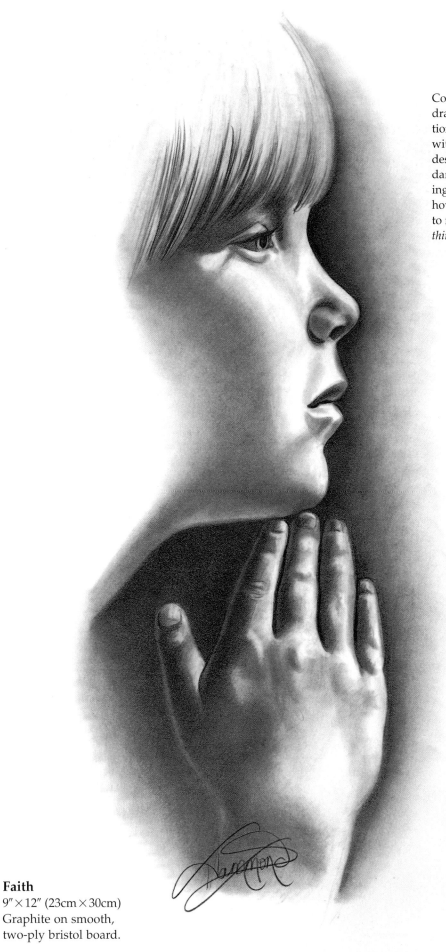

Contrast can be a crucial element in a drawing. This extreme lighting situation gives the drawing a beautiful effect with a lot of visual impact. The hand is described by the patterns of light and dark, with parts of the hand actually being hidden in the darkness. This shows how important it is to draw shades and to not draw from memory (or what we *think* something should look like).

Faith
9″ × 12″ (23cm × 30cm)
Graphite on smooth,
two-ply bristol board.

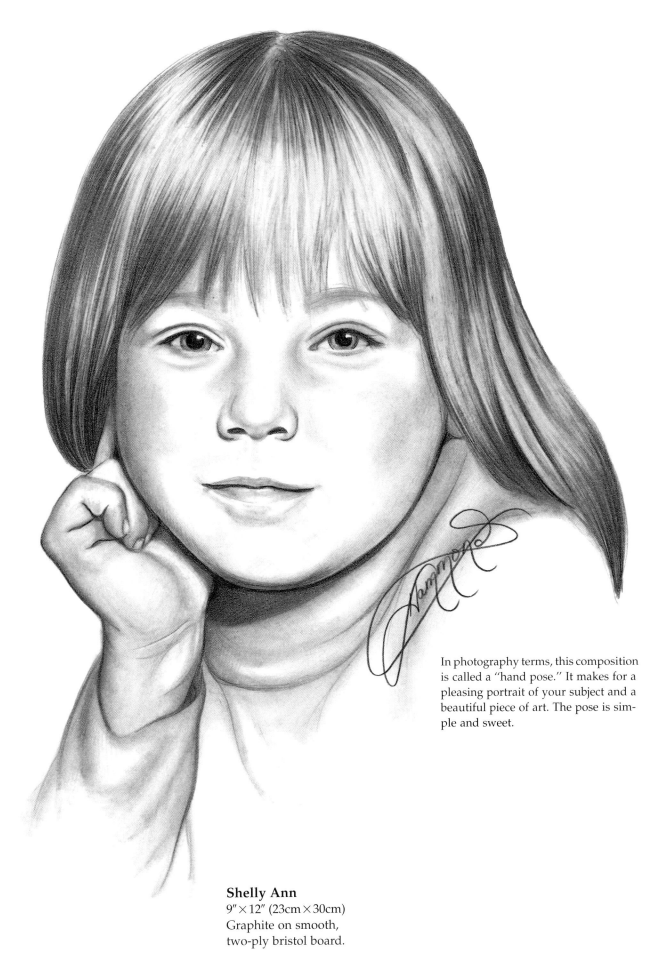

In photography terms, this composition is called a "hand pose." It makes for a pleasing portrait of your subject and a beautiful piece of art. The pose is simple and sweet.

Shelly Ann
9″ × 12″ (23cm × 30cm)
Graphite on smooth,
two-ply bristol board.

CONCLUSION

Artwork is only as good as the weakest areas presented in the picture. Hopefully, hands are no longer that weak area for you. Hands are no doubt a trouble spot for many artists, but they are a very important aspect of any composition. They mean more to a composition than most people realize by helping to tell a visual story about the subject.

As you can see, this drawing technique can be used to render anything! Drawing a hand is no more difficult than drawing a tennis shoe or a tugboat if it is seen as shapes, lights and darks! Follow the drawing "recipe" correctly, and you can draw anything your heart desires. It only takes practice, determination, dedication to learning and more practice.

I hope you will now include rather than avoid hands in your artwork; by avoiding them, you are eliminating an opportunity to create some wonderful pieces. I also hope that a door has been opened for you and you will be excited by the many possibilities.

Keep up the good work, but most of all . . . have fun!

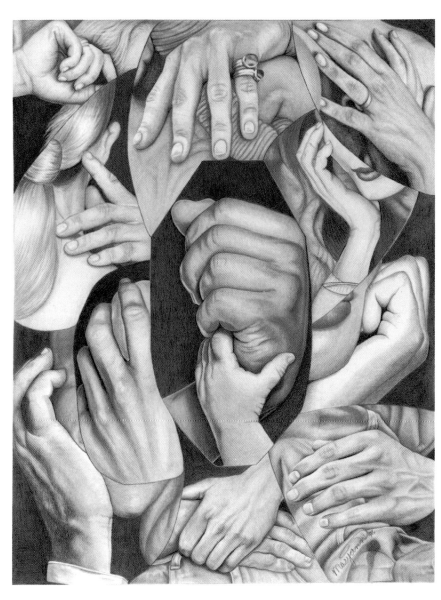

Montage of Hand Poses
by Mary Ann Mook
16″ × 20″ (41cm × 51cm)
On #1008 Ivory mat board.

INDEX

THE END

Oops. Wrong book!

More Great Books for Beautiful Art!

Discover Drawing Series—Explore the pleasures of drawing with professional artist and instructor, Lee Hammond! You'll be drawing realistic people and animals in no time as you follow comprehensive demonstrations designed to guide you every step of the way. Each paperback book is 80 pages long.

Draw Family & Friends!
#30952/$12.99/147 b&w illus.

Draw Real People!
#30720/$12.99/231 b&w illus.

Draw Real Animals!
#30762/$12.99/255 b&w illus.

Creating Radiant Flowers in Colored Pencil—Capture the rich textures of elegant orchids, graceful roses, cheery pansies and dozens of other blooms! Over 60 easy-to-follow demonstrations will help you master the techniques you need to create stunning florals in this popular medium. *#30916/$27.99/128 pages/181 color illus.*

A Step-by-Step Guide to Drawing the Figure—Draw the human form from start to finish with this comprehensive guide to figure rendering. Seventeen projects and over 400 color illustrations show you how to master essential principles of figure drawing—from perspective and shading to proportion and movement. *#30902/$24.99/128 pages/450 color illus./paperback*

1998 Artist's & Graphic Designer's Market: 2,500 Places to Sell Your Art & Design—Get the latest edition of this essential marketing tool for artists and graphic designers! 2,500 listings—700 of which are new—give you leads sorted by market, including greeting cards, magazines, posters, books and design firms. You'll also find helpful advice on selling and showing your work from art and design professionals, plus listings of art reps, artists' organizations and much more! *#10514/$24.99/786 pages/paperback*

First Steps Series: Drawing and Painting Animals—Discover how easy it is to draw and paint favorite pets, barnyard critters and wild animals. You'll learn how to simplify the process into easy-to-do steps—from creating basic shapes, to adding the necessary details that will bring your creation to life! *#30849/$18.99/128 pages/96 color illus./paperback*

Basic Colored Pencil Techniques—Follow along with clear and easy demonstrations as you explore the foundational techniques of this expressive medium. From layering to burnishing, you'll learn a variety of versatile techniques and how to apply them to create trees, flowers, animals, people and other popular subjects. *#30870/$17.99/128 pages/173 color illus./paperback*

First Steps Series: Drawing in Pen and Ink—Now you can draw sketches that actually look like your subjects! Popular instructor Claudia Nice guides you through step-by-step projects and simple techniques for creating realistic-looking trees, flowers, people and more. *#30872/$18.99/128 pages/200 illus./paperback*

How to Draw Portraits in Colored Pencil From Photographs—Create colored pencil portraits that only *look* as though they were difficult to draw! Professional portraitist Lee Hammond takes you from start to finish with simple instructions, color recipes, layering techniques and inspiring demonstrations. *#30878/$27.99/128 pages/261 color illus.*

Creative Colored Pencil Portraits—Explore the art of portrait drawing with advice from six experienced artists on every aspect of creating portraits—including working with a photo, developing a composition and mixing skin tones. *#30852/$16.99/84 pages/150 color illus.*

Sketching Your Favorite Subjects in Pen & Ink—The first complete guide—for all types and levels of artists—on sketching from life in pen and ink. Written by Claudia Nice, a master of the subject, this book is presented in easy-to-follow, step-by-step fashion. *#30473/$22.95/144 pages/175 b&w illus.*

How to Get Started Selling Your Art—Turn your art into a satisfying and profitable career with this guide for artists who want to make a living from their work. You'll explore various sales venues—including inexpensive home exhibits, mall shows and galleries. Plus, you'll find valuable advice in the form of marketing strategies and success stories from other artists. *#30814/$17.99/128 pages/paperback*

Creative Colored Pencil Landscapes—Explore the challenges of landscape drawing and uncover new ideas as you study the works of 15 professional artists. Nine projects demonstrate different approaches to drawing scenes from nature; nine others concentrate on elements that are particularly difficult to draw—water, sky and cityscapes. *#30858/$16.99/84 pages/150 color illus.*

Creating Textures in Pen & Ink With Watercolor—Create exciting texturing effects—from moss to metal to animal hair—with these step-by-step demonstrations from renowned artist/instructor Claudia Nice. *#30712/$27.99/144 pages/120 color, 10 b&w illus.*

Drawing Expressive Portraits—Create lifelike portraits with the help of professional artist Paul Leveille. His easy-to-master techniques take the intimidation out of drawing portraits as you learn the basics of working with pencil and charcoal; how to draw and communicate facial expressions; techniques for working with live models and more! *#30746/$24.99/128 pages/281 b&w illus.*

Creating Textures in Colored Pencil—Add new dimension to your colored pencil work with these techniques for creating a rich variety of texture effects. More than 55 lifelike textures are covered, using clear, step-by-step demos and easy-to-do techniques, plus special tricks for getting that "just right" look! *#30775/$27.99/128 pages/175 color illus.*

The Best of Colored Pencil III—Inspiration is just a page turn away with this collection of winners and exhibitors from the most recent Colored Pencil Society of America art shows. More than 200 imaginative drawings represent a wide array of subjects, styles and techniques—all presented in brilliant detail. *#30784/$24.99/160 pages/200+ color illus.*

Basic Figure Drawing Techniques—Discover how to capture the grace, strength and emotion of the human form. From choosing the best materials, to working with models, five outstanding artists share their secrets for success in this popular art form. *#30564/$16.99/128 pages/405 b&w illus./paperback*

Keys to Drawing—Proven drawing techniques even for those of you who doubt your ability to draw. Includes exercises, chapter reviews and expressive illustrations. *#30220/$22.99/224 pages/593 b&w illus./paperback*

The Pencil—Paul Calle begins with a history of the pencil and discussion of materials, then demonstrates trial renderings, various strokes, making corrections and drawing the head, hands and figure. *#08183/$21.99/160 pages/200 b&w illus./paperback*

The Complete Colored Pencil Book—Bernard Poulin's comprehensive book offers everything from how to buy the right tools, to how to draw rich landscapes and create textures, to how to outfit a portable studio. *#30363/$27.99/144 pages/185 color illus.*